VINCENT

A COMPLETE PORTRAIT

VINCENT

A COMPLETE PORTRAIT

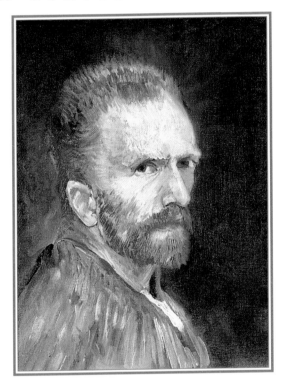

All of
Vincent van Gogh's Self-Portraits,
WITH EXCERPTS FROM HIS WRITINGS

BERNARD DENVIR

RUNNING PRESS • PHILADELPHIA, PENNSYLVANIA

Copyright © 1994 by Inklink

Concept, design, and editorial direction Simon Jennings.
Produced, edited, and designed at Inklink,
Greenwich, London, England.

Text © 1994 Bernard Denvir
Designed by Simon Jennings

Text edited by Ian Kearey
Additional design work Alan Marshall
Picture research Simon Jennings
Anne-Marie Ehrlich
Beth Williamson
Ian Kearey

**Published in The United States of America
by Running Press, Philadelphia, Pennsylvania**

Cover portrait: SELF-PORTRAIT IN A GRAY FELT HAT;
Paris, late 1887 / early 1888. Oil on canvas, 17¹⁄₁₆″ x 14¾″, Amsterdam,
Van Gogh Museum, Vincent van Gogh Foundation.

Cover design by Simon Jennings.

Text setting and computer make-up by Inklink, London.
Image generation by T. D. Studios, London.
Printed by Tien Wah Press, Singapore.

Canadian representatives: General Publishing Co., Ltd.,
30 Lesmill Road, Don Mills, Ontario M3B 2T6.

9 8 7 6 5 4 3 2 1
Digit on the right indicates the number of this printing.

Library of Congress Catalog Number 93-86322

ISBN 1-56138-407-0

This book may be ordered by mail from the publisher.
Please add $2.50 for postage and handling.
But try your bookstore first!
Running Press Book Publishers
125 South Twenty-Second Street
Philadelphia, Pennsylvania 19103-4399

VINCENT

A COMPLETE PORTRAIT

TABLE OF CONTENTS

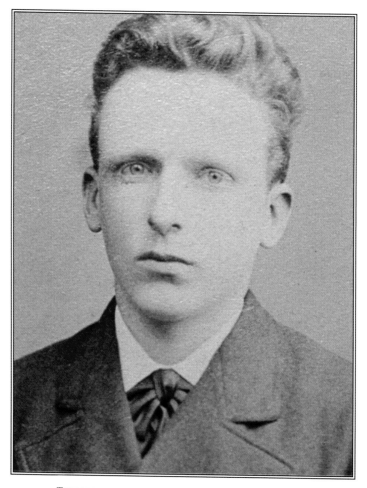

THE MOST RECENTLY DISCOVERED PORTRAIT PHOTOGRAPH OF
VINCENT VAN GOGH, FOUND IN THE COLLECTION OF HIS COUSIN, ANTON MAUVE.
RESEARCH SUGGESTS IT WAS TAKEN WHEN VINCENT WAS WORKING IN GOUPIL'S IN
THE HAGUE, SO HE WOULD HAVE BEEN BETWEEN
SIXTEEN AND TWENTY YEARS OF AGE.
(COURTESY OF RICHARD VAN DIJK)

"It isn't an easy Job to Paint Oneself"

In the course of four years, between 1885 and 1889, Vincent van Gogh painted more than forty self-portraits. It is a unique and an extraordinary achievement, not just in terms of artistic expression and experiment, but as a record of the pilgrimage through life of a human being. We know much about the anguish, terrors, self-doubt, mental miseries, and occasional pleasures of his life, thanks to his prolific correspondence, mainly to members of his family. No other artist has revealed so much about himself.

Self-portraits are no new thing. In the sixth century before Christ, Theodorus of Samos cast a bronze portrait of himself, holding in his right hand a file, and in his left a model of a chariot he had made. Medieval scribes used to draw themselves in the margins of their manuscripts, often with some complaint about the difficulties of their task issuing from their mouths. Ghiberti added his own picture to the famous bronze doors of the Baptistery in Florence. Dürer's face is known to us from the various drawings and paintings he made of himself. Above all there was Rembrandt, who in sixty paintings and some twenty engravings converted the self-portrait ("a self seeing a self seeing a self," as it has been defined) from an artistic

exercise into an instrument of psychological interrogation. These paintings reveal for all posterity every phase of his life with remorseless, investigative honesty, from the swaggering confidence of early manhood to the melancholy resignation of old age.

But van Gogh's analysis of himself was spread more intensely, over a shorter time – four years rather than forty – and on the whole it was more deeply interrogative than Rembrandt's. He had always been suspicious of photography, even as an instrument of record. Only three portrait photographs of him exist, all taken before he was twenty-one, and he does not face the camera in the few other photographs known. He wrote to his sister Willemina:

"These photographic portraits wither much sooner than we ourselves do, whereas the painted portrait is a thing which is felt, done with love or respect for the human being that is portrayed."

His first moves into portraiture were mostly motivated by economic incentives. Towards the end of 1884 he felt that he could make a living by doing portraits; this resolve was confirmed by the fact that his friend van Rappard, a fellow student at the Antwerp Academy, had also started portrait painting. Van Gogh chose to paint peasants, whom he paid with gifts; from heads, he graduated to full figures.

By the end of 1885 he was producing vigorously painted

portraits, such as that of a nurse, or *The Head of an Old Man like Victor Hugo* (both to be found in Amsterdam, at the Van Gogh Museum).

It was at this time that Vincent started painting self-portraits. His reasons for doing this were mixed. Foremost, there was the question of expense: models needed to be paid in one way or another, and it cost nothing to paint himself. On the other hand, however, most of the subjects of his portraits, especially those which have become most famous – the Roulin family, Eugène Boch, Dr. Rey, "L'Arlésienne," Agostina Segatori, and Lieutenant Milliet – were not paid models. In fact van Gogh tended to emphasize the cost of his portrait-painting activities largely to justify his financial demands on his brother Theo.

What is apparent in the early self-portraits painted in Antwerp is that, right from the start, they became, and remained, ploys in the strategy of his life. They confirmed, explored, or exploited some or other aspect of his ego.

Self-portraiture often involves the presentation of a self which does not coincide with reality; and in the same way that Dürer and Rembrandt might present themselves in their paintings or drawings as playing parts superior to their real ones, van Gogh often indulged in role-playing. The very first of his painted self-portraits (see page 23)

shows him standing in front of an easel, smartly dressed and even wearing a hat, as if to emphasize his respectability. He is conforming to the standards of the Antwerp Academy and of friends such as van Rappard, and aiming to impress his brother Theo with his seriousness. So too, when he first arrived in Paris, and even after the impact of Impressionism had lightened his palette, he would intermittently present himself to the world in suit, collar, tie, vest, and Homburg hat.

But this was not the only part he played. He wrote to Theo from Arles in 1888 about the self-portrait he was sending to Gauguin:

"If I might be allowed to stress my personality in a portrait, I have done so in trying to convey in my portrait not only myself, but an Impressionist in general, and have conceived it as a portrait of a simple 'bonze,' a worshiper of the eternal Buddha."

The clothes he wears according to circumstances – those of a peasant or his "professional clothes with a blue smock" – the hats he puts on, whether he has a full beard, a short beard, or is clean-shaven; all these are clues to the part he is playing in the drama of his own life.

Anxious to reassure Theo (and no doubt himself) shortly after leaving the hospital at Arles before traveling to Saint-Rémy, he wrote:

"I am sending you my own portrait today, you must look at it for some time; you will see that my face is much calmer, though to me it seems vaguer than before. Show it to old Pissarro when you see him."

In September 1889 Vincent painted a self-portrait to send his mother for her seventieth birthday; in it he presented himself as the clean-shaven, young, and unworried man he used to be, not the harassed, dishevelled creature he had become (see page 103).

It would, however, be a total misapprehension to see in van Gogh's pictures of himself nothing more than exercises in studied self-presentation. Few men have shown so painstakingly in their writings and in their paintings, the search for the nature of their identity. The very number and diversity of his self-portraits is proof of this. It was a search carried on at two levels. The first was a more general one, of the kind that exercises most people at some time or other in their lives, about who and what they are.

The second was more specific to van Gogh. Experts still disagree about the nature of his mental problems, but an element of heredity was certainly involved: both his brother Theo and his youngest sister Willemina suffered from very similar psychotic illnesses. Whatever the precise nature of van Gogh's mental state, it was almost certainly aggravated

by drinking excessive amounts of alcohol – especially absinthe, which was so dangerous that it was made illegal a few years after his death. His problems would have been worsened by contracting syphilis (from which Theo also suffered). But van Gogh was aware of his mental state, and he could talk fluently and coherently about it during the last five years of his life, even before its more obvious effects had become frighteningly apparent.

His self-portraits are both an unconscious form of self-therapy, and an attempt to conquer "The business that walks by night, the devil that flieth by noonday." The fear so often seen in his eyes suggests an awareness of the forces of unreason that were always threatening to overcome him. When he sends news to Theo that he is calm again, he often "verifies" it with a portrait, always believing that it will contain a truth hidden not only from the lens of the camera, but even from the rational mind. We can still see that truth in all its facets, in these paintings. He achieved the ambition that he described in a letter to Willemina in June 1890:

> "I should like to paint portraits which would
> appear after a century to the people living
> then as apparitions."

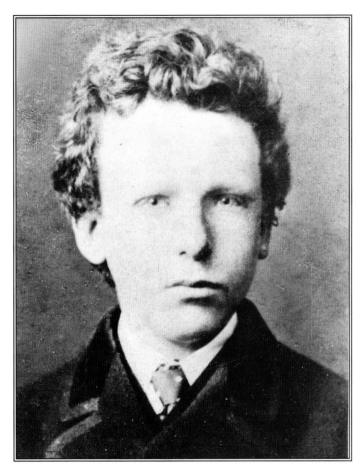

VINCENT VAN GOGH AGE THIRTEEN
1866
AMSTERDAM, VAN GOGH MUSEUM
VINCENT VAN GOGH FOUNDATION

CHRONOLOGY

1853

MARCH 30. Vincent van Gogh born at Groot-Zundert in the Dutch province of Brabant, on the Belgian frontier. He is the eldest surviving child of Theodorus van Gogh, the minister of the town, and Anna Carbentus.

1857

MAY 1. Theo van Gogh born.

1861

First attends the village school.

1869

JULY 30. Joins the firm of Goupil and Co., art dealers in The Hague.

1873

MAY. Joins the London branch of Goupil, at a salary of £90 a year.

1874

AUGUST. Proposes to Eugenie Loyer, the daughter of his London landlady, and is rejected by her.

NOVEMBER. Transferred temporarily to the Paris branch of Goupil. Returns to the London branch early the next year.

1875

MAY. Sent back to the head office of Goupil in Paris, where he does not fit in. Involved in religious mysticism and intense Bible study.

1876

MARCH. Dismissed from Goupil's, gets a job as an assistant teacher at Ramsgate in April, before moving to the Jones's Methodist School at Isleworth, near London. At Christmas returns to Holland to see his family, which has moved to Etten in North Brabant, and stays there.

1877

JANUARY. Works in a bookshop at Dordrecht until April.

MAY 9. Moves to Amsterdam, intending to get a degree in theology at the University and then enter the ministry.

1878

JULY. Moves to Brussels, where he spends three months at a school for missionaries.

DECEMBER. Takes up an appointment as a lay-preacher near Mons, in the coal-mining area of the Borinage in the south of Belgium, preaching and working amongst the sick at his own expense.

1879

JANUARY. Moves to Wasnes in the same area, but is dismissed for excessive zeal, and goes to work at a nearby village.

1880

Cultivates his new ambition to be an artist, drawing miners, and copying works by Millet and other artists.

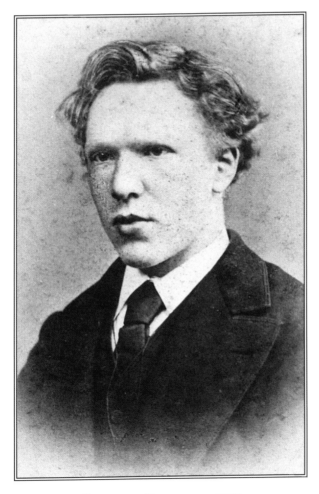

Vincent van Gogh age nineteen
early 1873
Amsterdam, Van Gogh Museum
Vincent van Gogh Foundation

1880

OCTOBER. Goes to Brussels to take lessons in anatomy and perspective. Theo begins to support him financially.

1881

APRIL 12. Returns to Etten and lives with his family. Begins correspondence with the Dutch painter Anton van Rappard.

AUGUST. Is rejected by his widowed cousin, Cornelia ("Kee") Vos, with whom he has fallen in love.

NOVEMBER. Moves to The Hague and starts studying under Anton Mauve, leader of the school of Laren, based on the style of the Barbizon painters, but leaves after a few weeks.

1882

In The Hague lives with a prostitute, Clasina Hoornik, known as "Sien."

JUNE. Enters hospital for a short time. Becomes interested in oil painting. His family moves from Etten to Nuenen, near Eindhoven.

1883

SEPTEMBER. Theo persuades him to leave Sien. Moves to Drenthe in north-east Holland, before joining his family.

1884

Has a relationship with a neighbor, Margot Begemann, which ends unhappily when she tries to commit suicide. Paints still lifes, pictures of weavers, and studies of peasants' heads

for a large painting, *The Potato Eaters.* Theo arranges to pay him 150 francs a month in return for his paintings.

1885

MARCH 26. Death of his father, Theodorus van Gogh.

MAY. Paints *The Potato Eaters.*

NOVEMBER. Moves to Antwerp and enters the Art Academy for a short time, during which he studies Rubens.

1886

FEBRUARY 28. Travels to Paris and lives with Theo in the rue de Laval. Joins the studio of Cormon and meets many Parisian artists, including Toulouse-Lautrec, Emile Bernard, Gauguin, and Signac. Exhibits at a café, Le Tambourin.

1887

Works at Asnières with Emile Bernard. Meets Degas and becomes interested in Post-Impressionism.

1888

FEBRUARY 20. Moves to Arles in Provence, where he rents first a room over the Restaurant Carrel, and then the right wing of "The Yellow House" in Place Lamartine, which he does not occupy until September. Spends June by the sea at Saintes-Maries-de-la-Mer, where his favorite artist, Monticelli, used to paint.

OCTOBER 23. Gauguin arrives from Pont-Aven in Brittany.

DECEMBER 23. Has mental crisis and cuts off part of his ear. Theo visits him and then returns to Paris with Gauguin.

1889

JANUARY 7. Leaves hospital, where he has been since the incident.

FEBRUARY. Has two further mental breakdowns followed by hospitalization.

MAY 8. Moves voluntarily to the nearby asylum of Saint-Paul-de-Mausole at Saint-Rémy, and paints there, in his room or outside in the park. Has two more violent attacks there, in July and around Christmas, but is lucid and aware the rest of the time.

1890

JANUARY. Has another breakdown. An article about his work by Albert Aurier is published in the *Mercure de France*. Theo's son is born.

FEBRUARY. One of his paintings, *The Red Vineyard*, is sold in Brussels for 400 francs. Suffers another attack from mid-February to mid-April.

MAY 16. Returns to Paris to visit Theo. Pissarro suggests that Dr. Gachet, friend and patron of the Impressionists, looks after him at Auvers-sur-Oise.

MAY 20. Arrives at Auvers and takes rooms at an inn run by Arthur-Gustave Ravoux and his family.

JULY 27. Shoots himself in a field, and dies two days later.

JULY 30. Buried in the cemetery at Auvers.

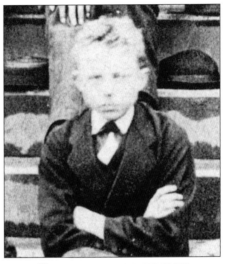

VINCENT IN A CLASS PHOTOGRAPH
AGE THIRTEEN OR FOURTEEN,
AT SCHOOL IN TILBURG IN 1867
(COURTESY OF THE KING WILLEM II SCHOOL, TILBURG)

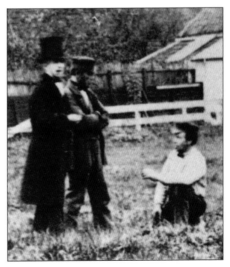

VINCENT AS A SMARTLY DRESSED YOUNG MAN,
WITH TOP HAT AND FROCK COAT,
PROBABLY IN DORDRECHT IN 1877
(COURTESY OF THE MUNICIPAL ARCHIVES, DORDRECHT)

THE SELF-PORTRAITS

ESCRIPTIONS OF VAN GOGH at the time he was attending the Antwerp Academy tally with the sketches he drew of himself in a sketchbook. Judging from the miscellaneous information this contains, he must always have carried it about with him (seven such books have survived).

The short, thick jacket, "the kind bargemen usually wear," and the fur cap "he always wore on his head" can clearly be seen.

The vigor of the hatching strokes of the black chalk is similar to that of his brushstrokes in oil painting. The drawing shows considerable skill in expressing a quite complicated pattern of light and shade.

SELF-PORTRAIT FROM SKETCHBOOK (RECTO)
ANTWERP, LATE 1885
BLACK CHALK ON PAPER, 7¾IN X 4¼IN (19.7CM X 10.9CM)
AMSTERDAM, VAN GOGH MUSEUM
VINCENT VAN GOGH FOUNDATION

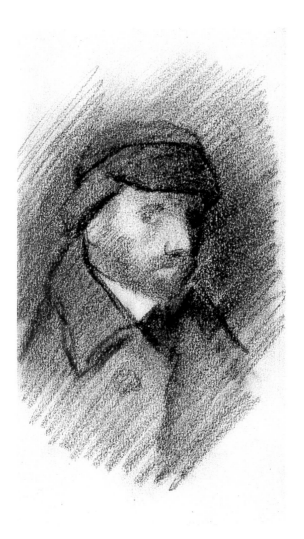

OTH THIS AND THE PREVIOUS
sketch, of which this is the verso, seem to have
been exercises in expressing light and shade in
terms of pure drawing. They are probably the
fruits of the lessons of Eugeen Siberdt, the drawing
master at the Antwerp Academy. At this time,
Vincent was toying with the idea of making money
by painting portraits – notably under the influence
of Rubens – and he did in fact produce several.
These two drawings were practice for perfecting
the genre.

*"The thing is to learn to draw well, to be master of
my pencil, or my crayon, or my brush; this gained, I
shall make good things anywhere . . ."*

The sketchbook also notes appointments with a
Dr. Cavenaille, who was treating van Gogh for the
syphilis that he had contracted from his frequent
visits to the brothels by the docks, and the
treatments he was taking.

SELF-PORTRAIT FROM SKETCHBOOK (VERSO)
ANTWERP, LATE 1885
BLACK CHALK ON PAPER, 7¾IN X 4¼IN (19.7CM X 10.9CM)
AMSTERDAM, VAN GOGH MUSEUM
VINCENT VAN GOGH FOUNDATION

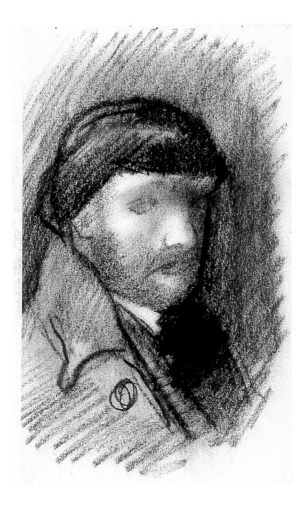

HIS PAINTING, WHICH WAS badly damaged in a fire at Laren in 1941 when it was in the possession of Theo's son, Vincent Willem van Gogh, is the first self-portrait in oils that van Gogh painted. It shows the artist standing at an easel which supports a canvas. He is holding a palette containing a variety of colors, notably two shades of red, and a creamy-white.

". . . Rubens is certainly making a strong impression on me. . . . I am quite carried away by his drawing the lines of a face with streaks of pure red . . ."

Even allowing for the scorching of the paint, the colors are very dark, and the only bright patches are the beard and mustache. Curiously, considering that he is painting, Vincent is wearing a dark felt hat; this is presumably intended to lend him an air of dignity. The dark green tonality of the background is unusual, and does not feature in most of the other self-portraits.

SELF-PORTRAIT OF THE ARTIST AT HIS EASEL
PARIS, EARLY 1886
OIL ON CANVAS, 18⁵⁄₁₆IN X 15¹⁄₈IN (46.5CM X 38.5CM)
AMSTERDAM, VAN GOGH MUSEUM
VINCENT VAN GOGH FOUNDATION

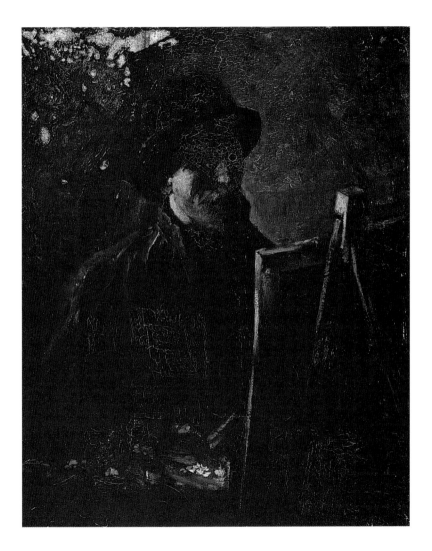

HIS, THE MOST RECENTLY discovered self-portrait of van Gogh, was found in 1952 in the cellars of the Stedelijk Museum in Amsterdam. It had been deposited there by Vincent Willem van Gogh, Theo's son.

It is part of a trio, all painted in melancholic colors, that accurately reflect Vincent's physical problems at the time. In Antwerp he had starved himself to buy materials, he had been undergoing palliative treatment for his syphilis, and he had had ten teeth extracted, at a cost of 50 francs. This last trial prompted him to grow his mustache as a form of camouflage, and explains the "hissing" tone that observers and friends noted in his speech.

"*. . . I still have to suffer much, especially from those peculiarities that I cannot change . . . my appearance, and my way of speaking, and my clothes . . .*"

SELF-PORTRAIT WITH DARK FELT HAT
PARIS, EARLY 1886
OIL ON CANVAS, 16⅛IN X 12¾IN (41CM X 32.5CM)
AMSTERDAM, VAN GOGH MUSEUM
VINCENT VAN GOGH FOUNDATION

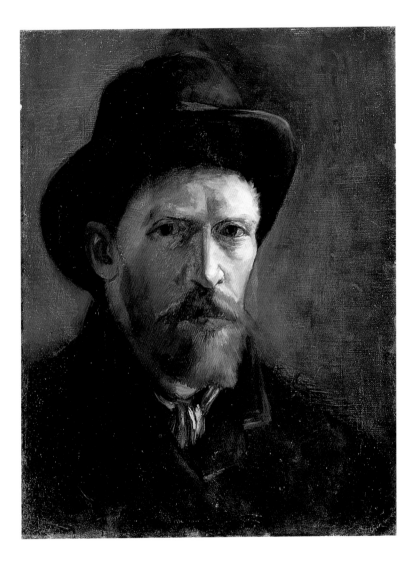

DRESSED IN THE SAME SUIT, with the same blue cravat as in the previous and following paintings, van Gogh adopts a similar tonality and uses the same emphatic lighting effects. The light falls most strongly on the left side of his face and forehead in all three paintings, and his right side virtually disappears into the background.

"Simply stated, the picture should stir the head, or, more properly, the fantasy."

The red of burning tobacco in the pipe strikes a dramatic note. The background was probably a degree or two lighter than it is now, and, as with all this group of paintings, there is a good deal of cracking of the pigment, possibly indicating Vincent's use of bitumen.

SELF-PORTRAIT
PARIS, EARLY 1886
OIL ON CANVAS, 18⅛IN x 15IN (46CM x 38CM)
AMSTERDAM, VAN GOGH MUSEUM
VINCENT VAN GOGH FOUNDATION

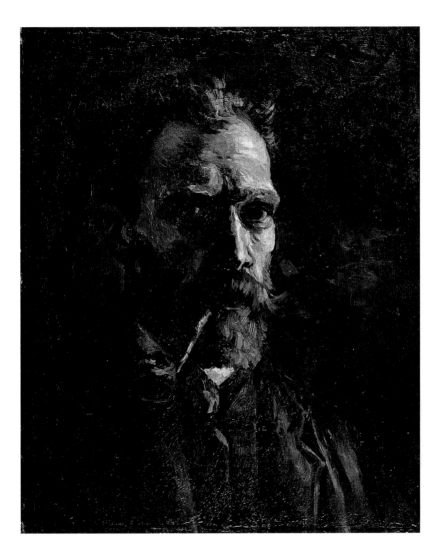

THIS VERSION IS ALMOST a half-length portrait, not one of Vincent's usual formats for self-portraits, although he does not detail the jacket beyond the aperture showing the collar and cravat. The dress is still formal and the tonality melancholy. The background is very lightly scrubbed-in, revealing in places the texture of the canvas. The strong light on the forehead strikes a very dramatic note, emphasized by the contrast between the glowing configuration of the beard and the greenish pallor of the forehead. It shows van Gogh at his most haggard-looking.

"I have lived . . . without any money for a dinner, because the work costs me too much, and I have relied too much on my being strong enough to stand it . . . I have made it worse by smoking a great deal, which I did the more because then one does not feel an empty stomach so much . . ."

SELF-PORTRAIT
PARIS, EARLY 1886
OIL ON CANVAS, 10⅝IN X 7½IN (27CM X 19CM)
AMSTERDAM, VAN GOGH MUSEUM
VINCENT VAN GOGH FOUNDATION

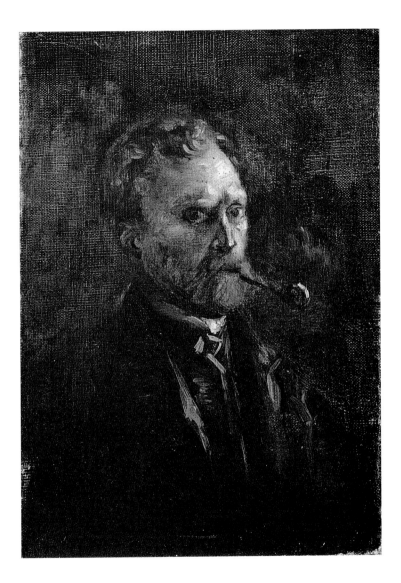

A PPARENTLY
this was originally painted in the spring of 1886. It shows the self-confidence which was beginning to infuse van Gogh's work as a consequence of his going to Cormon's studio. Unlike any of his other self-portraits of this time, it is signed "Vincent" in black paint in the top left-hand corner.

The visible cracking, particularly on the jacket, suggests the possible use of bitumen. This was much used by society portraitists of the time to obtain a high finish; van Gogh seems never to have used it again. The evidence suggests that he returned to this self-portrait and touched it up some time later, probably in the following year.

SELF-PORTRAIT
PARIS, 1886-7
OIL ON CANVAS, 24IN X 19¹¹/₁₆IN (61CM X 50CM)
AMSTERDAM, VAN GOGH MUSEUM
VINCENT VAN GOGH FOUNDATION

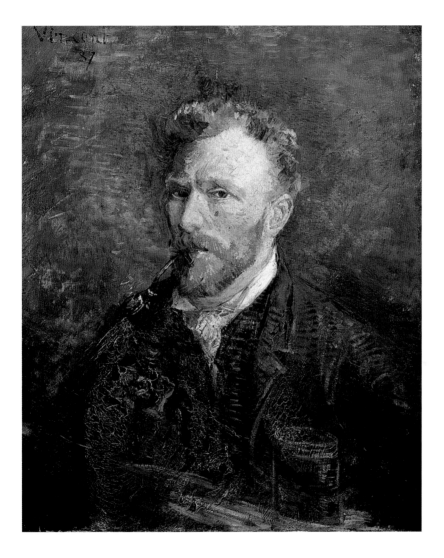

AINTED SOON AFTER VINCENT'S arrival in Paris in February 1886, this picture presents a far more self-assured image than in the earlier portraits. He wrote at the time,

". . . however hard living may be here, and even if it became worse and harder – the French air clears up the brain and does good . . ."

There are signs of the influence that the works of Rubens had had on his work in Antwerp, particularly in the reddish tinge of the face. Vincent also gives a great deal of attention to the very careful modeling of the flesh, especially around the eyes. This is the first appearance of the piping on his jacket – in this case a velvet one – that can be seen on many of the clothes he wears in his Parisian self-portraits.

SELF-PORTRAIT
PARIS, EARLY 1886
OIL ON CANVAS, 15½IN X 11⅝IN (39.5CM X 29.5CM)
THE HAGUE, HAAGS GEMEENTEMUSEUM

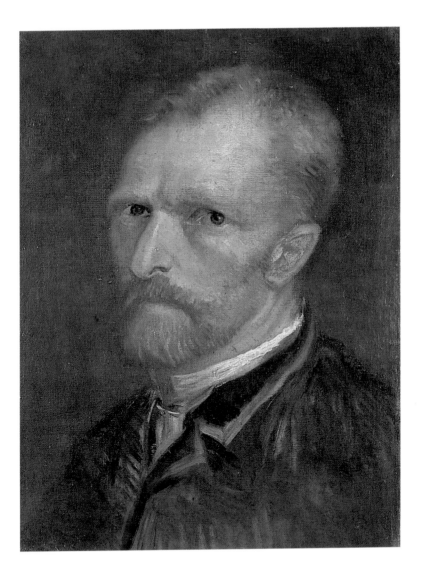

O N VINCENT'S DEATH, many of his paintings were in the possession of his brother Theo. When Theo died in 1891, they passed to his widow, Johanna van Gogh-Bonger. She sold this one to the Tietz family, art dealers in Cologne. It then passed into the collection of Joseph Wintherbotham, who deposited it with the Art Institute in Chicago. It was clearly painted at the time when van Gogh was experiencing the first impact of Signac's use of small "commas" of color – reds, browns, blues, greens, yellows, and whites – to build up the picture.

"There is something infinite in painting . . . it is so delightful just for expressing one's feelings. There are hidden harmonies or contrasts in colors which involuntarily combine to work together, and which could not possibly be used in another way . . ."

The effect can be best seen by contrasting this portrait with the previous one.

SELF-PORTRAIT
PARIS, 1886-7
OIL ON CANVAS, 16⅛IN x 12¾IN (41CM x 32.5CM)
CHICAGO, ART INSTITUTE
THE JOSEPH WINTERBOTHAM COLLECTION

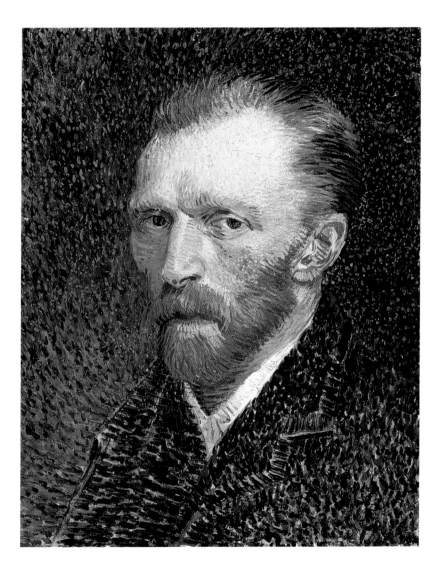

A LIGHTLY SKETCHED, but sharply observed drawing from life, this became the basis of a whole series of subsequent oil paintings. It may, however, have specifically been intended for the one on the previous page. This drawing and those on the next page are the only surviving examples of preliminary work on Vincent's own portraits, which he usually approached directly on the canvas. They do, however, give the lie to those critics who accuse van Gogh of technical incompetence. He wrote to Theo,

"In a word, [painting] is more gratifying than drawing. But it is absolutely necessary to be able to draw the right proportion and the position of the object pretty correctly before one begins. If one makes mistakes in this, the whole thing comes to nothing . . ."

SELF-PORTRAIT
PARIS, 1886-7
PENCIL ON PAPER, 7⅝IN X 8½IN (19.3CM X 21CM)
AMSTERDAM, VAN GOGH MUSEUM
VINCENT VAN GOGH FOUNDATION

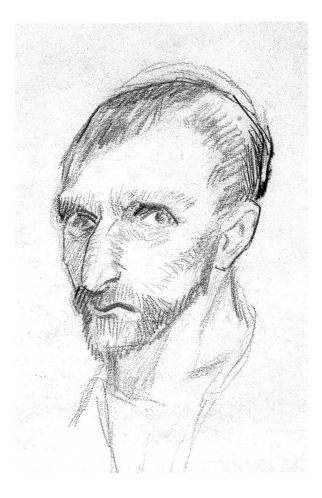

WHEN HE ATTENDED the Antwerp Academy, Vincent paid more attention to life-drawing than is usually accepted. In fact his academic skills, as illustrated on pages 31 and 33, are quite considerable, and all his self-portraits are based on a rigorous groundwork, as these drawings prove.

The upper face is more scrupulously studied than the lower, which is closer in feeling to his more generalized drawings of peasant women and working people. It is quite unlike the van Gogh we know from his oil paintings, or even from his earlier drawings at Nuenen.

THREE STUDIES FOR SELF-PORTRAITS
PARIS, 1886-7
LEAD PENCIL, AND PEN AND INK ON PAPER,
12⅜IN X 9⅝IN (31.5CM X 24.5CM)
AMSTERDAM, VAN GOGH MUSEUM
VINCENT VAN GOGH FOUNDATION

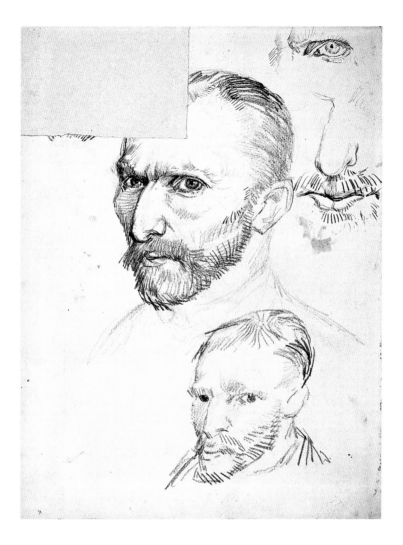

ERE IS THE FIRST self-portrait to show the effect that Impressionism exerted on van Gogh's style. He was slow to understand it, and never fully appreciated all its implications, but what he saw transformed his sense of color. He wrote to his sister Willemina,

"Always remember that what is required in art nowadays is something very much alive, very strong in color, very much intensified."

This scintillating exercise in radiant blue, interspersed with red, browns, and light grays, is a world away from the somber tones of his Dutch works. He also presents himself as a person of self-confidence and worldly comportment, though there is perhaps another feeling underneath.

"The more ugly, ill, poor I get, the more I want to take my revenge by producing a brilliant color, well-arranged, resplendent."

SELF-PORTRAIT WITH GRAY FELT HAT
PARIS, SPRING 1887
OIL ON CARDBOARD, 7½IN X 5½IN (19CM X 14CM)
AMSTERDAM, VAN GOGH MUSEUM
VINCENT VAN GOGH FOUNDATION

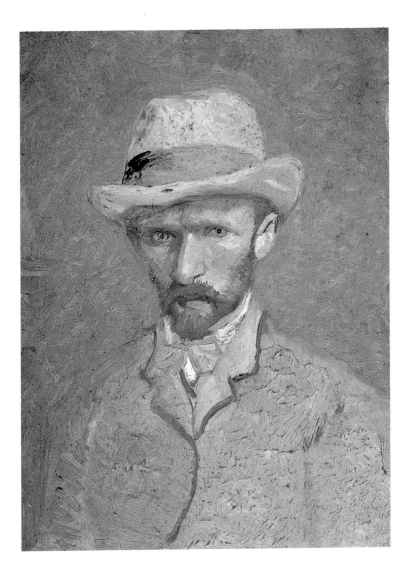

THE SKETCH-LIKE QUALITY of this self-portrait is accentuated by the perfunctory handling of the shoulders and jacket. The nose is thicker and shorter than is shown in most of Vincent's self-portraits, and the background does not integrate and define the shape and plasticity of the head as skillfully as in other paintings. What is remarkable, however, is the blue tonality that accentuates the melancholy quality; this, combined with the defensive, even shifty look on the face, gives the whole portrait a convict-like appearance.

"I would very much like to paint portraits which in a hundred years' time will be revelations . . ."

SELF-PORTRAIT
PARIS, SPRING 1887
OIL ON CARDBOARD, 7½IN X 5½IN (19CM X 14CM)
AMSTERDAM, VAN GOGH MUSEUM
VINCENT VAN GOGH FOUNDATION

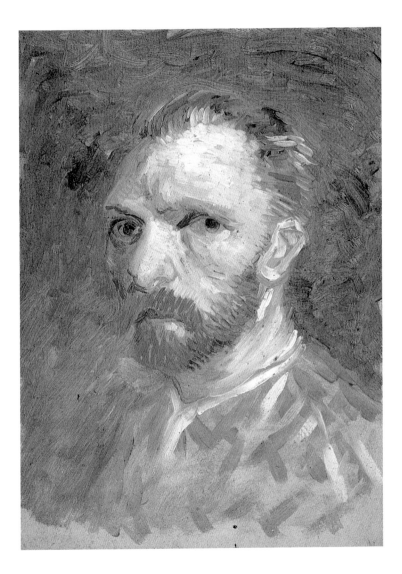

THIS PORTRAIT, which is generally accepted as belonging to the early part of 1887, is a remarkable leap into the future. Its vivid contrast of pure colors, short brushstrokes, and its sense of assurance all look forward to the style that would reach its flowering in Provence. The subtle interplay of blues – in the background, in the jacket with its piped lapels, in the neatly tied bow, and in the shadows on the chin, cheeks, and around the eyes and forehead – contrasts with the vivid explosion of yellow that is the hat. Here van Gogh is reaching away beyond the Impressionistic style that had captivated him, and is reacting not only to Monticelli,

"*. . . that excellent painter . . . the logical colorist,*"

but perhaps, at the same time, a little to his drinking companion Toulouse-Lautrec.

SELF-PORTRAIT WITH STRAW HAT
PARIS, SPRING 1887
OIL ON CARDBOARD, 7½IN X 5½IN (19CM X 14CM)
AMSTERDAM, VAN GOGH MUSEUM
VINCENT VAN GOGH FOUNDATION

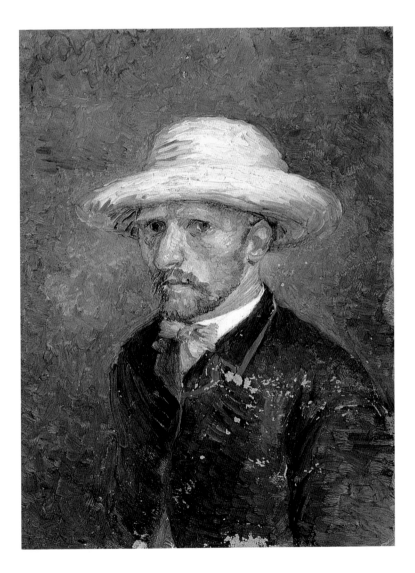

THE SERIES OF FOUR
self-portraits consisting of this one and the three following, were painted when van Gogh was going through a difficult time. He was especially concerned with examining his condition, both physical and psychological. He was aware that he had syphilis, he was drinking heavily, and he was disillusioned with the machinations of the Paris art world. Theo was courting Johanna Bonger, the sister of his friend Andries, and Vincent was increasingly obsessed with the idea that life was passing him by. He wrote about this period to Gauguin from Arles,

"I left Paris seriously sick at heart and in body, and nearly an alcoholic because of my rising fury at my strength failing me . . ."

His moods alternated capriciously, yet during this time he was also painting lyrical views of Montmartre.

Self-portrait
Paris, spring 1887
Oil on canvas, 16⅛in x 13in (41cm x 33cm)
Amsterdam, Van Gogh Museum
Vincent van Gogh Foundation

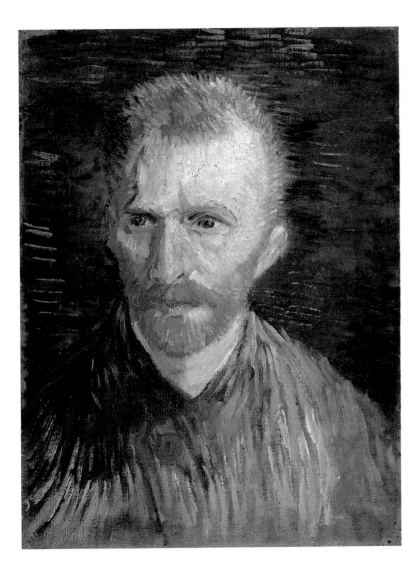

ERE, VINCENT'S FACE
is modeled by the strong lighting that projects it
against the very dark background. This in turn is
painted onto a grayish-umber foundation, clearly
seen down the left-hand side of the canvas. The
loose application of the dark brushstrokes creates a
kind of vibrancy around the head, which is
rendered very meticulously. The brownish eyes
look, in Hartrick's word, "suspicious." Vincent
himself wrote to Theo,

*"I much prefer painting people's eyes to cathedrals.
For deep in a human eye there's something that a
cathedral does not have – however impressive and
solemn it may be. I am more interested in the human
soul, be it the soul of a poor devil or that of a harlot, than
in structures."*

The horizontal strokes of the background
contrast with the diagonal and vertical strokes
of the jacket.

SELF-PORTRAIT
PARIS, SUMMER 1887
OIL ON CANVAS, 16½IN X 13⅜IN (42CM X 34CM)
AMSTERDAM, VAN GOGH MUSEUM
VINCENT VAN GOGH FOUNDATION

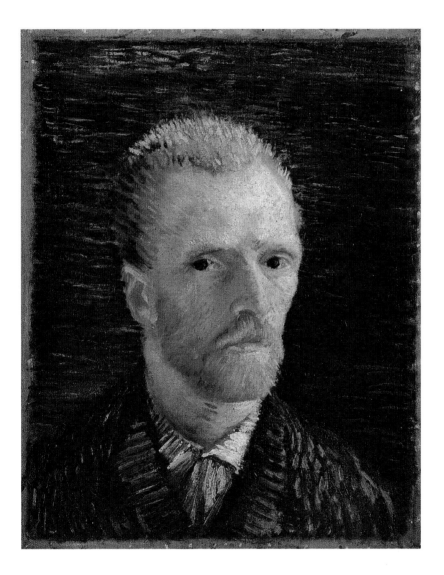

I N THIS VERSION of the themes first stated in the previous painting, van Gogh experiments still further with the patterns of horizontal brushstrokes in the background. These are now more elaborate, and though they produce the same flickering effect, they are used much more dramatically, creating a kind of halo of light.

Vincent's forehead and the upper part of his face emerge from this halo in a theatrical manner, reminiscent of some of Rembrandt's self-portraits. Although this was painted at about the same time as the previous one, van Gogh's face is more relaxed here. At the same time, however, he was writing to Willemina,

". . . my own adventures are restricted chiefly to making swift progress toward growing into a little old man, you know, with wrinkles and a tough beard, and a number of false teeth, and so on."

SELF-PORTRAIT
PARIS, SUMMER 1887
OIL ON CARDBOARD, 16¾IN X 12⅜IN (42.5CM X 31.5CM)
AMSTERDAM, VAN GOGH MUSEUM
VINCENT VAN GOGH FOUNDATION

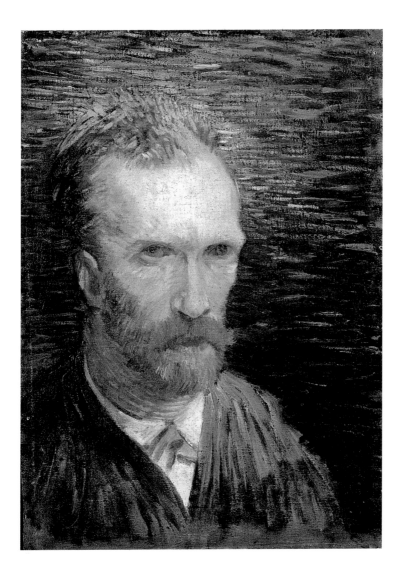

A PORTRAIT closely related to the three preceding ones, this features van Gogh's short hair, and the growth of beard on his cheeks. There is, however, a marked pallor in his complexion, accentuated by the strong light that has been focused on the forehead. Through the darkness of the background a radiance, like St. Elmo's fire, outlines the back and top of the head.

"I want to paint men and women with that something of the eternal which the halo used to symbolize, and which we seek to convey by the actual radiance and vibration of our coloring."

The background itself is so lightly brushed in that the texture of the canvas shows through, but the painter's smock is treated with immense vigor. The eyes look strongly self-interrogative.

SELF-PORTRAIT
PARIS, SUMMER 1887
OIL ON CANVAS, 15⅝IN X 13¼IN (39.7CM X 33.7CM)
HARTFORD, CONNECTICUT, WADSWORTH ATHENEUM
[GIFT OF PHILIP L. GOODWIN
IN MEMORY OF HIS MOTHER, JOSEPHINE S. GOODWIN]

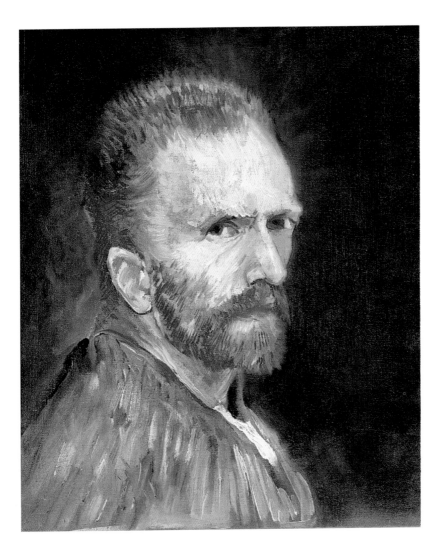

HIS WAS PROBABLY PAINTED at the same time as the following portrait. Apart from the iconographical resemblances – the same clothes, and the same hat – they are both painted on virtually identically-sized canvases. They are less technically developed than the third of the straw-hat series (see page 65). By then, Vincent had mastered a much more complex pattern of brushwork, richness of impasto, and intensity of observation. This version is one of the few later self-portraits showing him with the pipe to which he was so hopelessly addicted, and about which he wrote to Theo,

"I strongly advise you to smoke a pipe; it is a good remedy for the blues, which I happen to have now and then lately . . ."

There is a look of querulous anger about the face, and one gets a feeling of the vague sense of unease felt by some who met him.

SELF-PORTRAIT
PARIS, SUMMER 1887
OIL ON CANVAS, 16⅜IN X 12⅜IN (41.5CM X 31.5CM)
AMSTERDAM, VAN GOGH MUSEUM
VINCENT VAN GOGH FOUNDATION

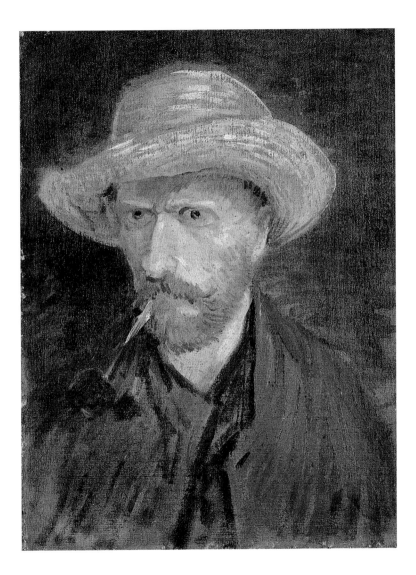

THIS IS ONE OF VAN GOGH'S least gripping self-portraits, although the technical presentation is convincing enough. The horizontal lines of the blue background that partly continue across and round the hat, lack something of the energy of the more convoluted, vertical brushstrokes that cascade across most of his other self-portraits. The modeling of the white collar or neckerchief is also very sketchy. The face, on the other hand, is realized in a strong light, with great care and precision.

". . . if I can manage to paint the coloring of my own head, which is not to be done without some difficulty, I shall likewise be able to paint the heads of other good souls . . ."

The general impression lacks passion: the expression is reflective, and the eyes are thoughtful. It is a complete contrast to the previous painting.

SELF-PORTRAIT WITH STRAW HAT
PARIS, SUMMER 1887
OIL ON CANVAS, 16⅛IN X 12¼IN (41CM X 31CM)
AMSTERDAM, VAN GOGH MUSEUM
VINCENT VAN GOGH FOUNDATION

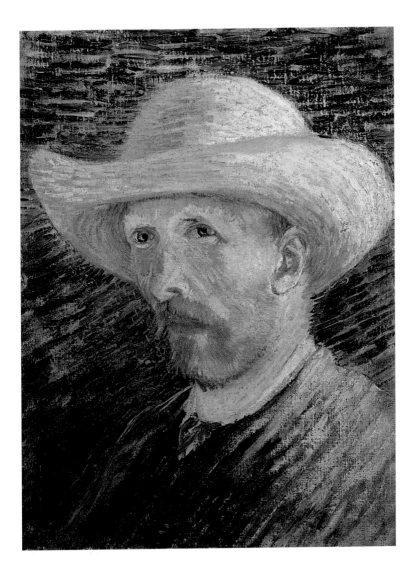

I T IS DIFFICULT TO SAY whether van Gogh considered this to be finished. The head and shoulders are painted with considerable precision, and he pays special attention to the right eye and its shadows, the emphatic line of the nose, the slightly open mouth, and the searching look on the face.

Despite all this, the background seems to be more an indication of what Vincent had in mind than a finished work. It appears that he intended this to be a variation on an all-yellow theme against a turquoise background. The red piping on the vest also appears on page 63, and van Gogh refers to the straw hat as a *"hannekenmaaier"* (the type worn by a Dutch harvest laborer).

SELF-PORTRAIT WITH STRAW HAT
PARIS, SUMMER 1887
OIL ON CARDBOARD, 15⅞IN X 12¾IN (40.5CM X 32.5CM)
AMSTERDAM, VAN GOGH MUSEUM
VINCENT VAN GOGH FOUNDATION

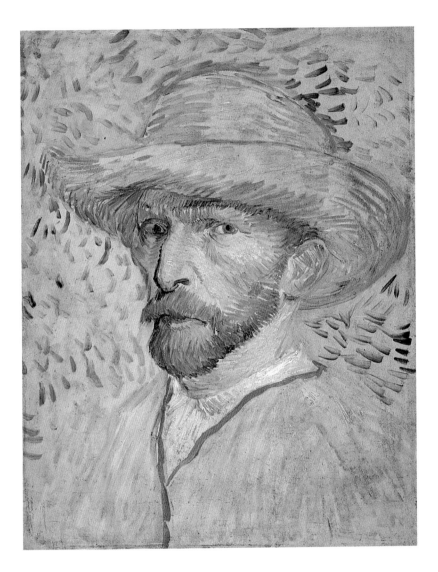

HIS WAS THE FIRST PAINTING by van Gogh to enter an American public collection. It was acquired by the Detroit Institute of Arts at the sale of the Dikran Khan Kelekian Collection, held at the American Art Association, New York, January 30-31, 1923.

Although the eyes are cautious and alarmed, the portrait has an atmosphere of summery radiance that looks forward to the paintings done later in Provence. Perhaps more than any of the other self-portraits of this period, this one reflects the extent to which Vincent's art had been liberated by his experience of Impressionism. There is a bold use of complementary colors, in touches such as the flecks of red that swirl over the top of the hat, and in the complex admixture of colors in the background.

SELF-PORTRAIT WITH STRAW HAT
PARIS, SUMMER 1887
OIL ON CANVAS, MOUNTED ON WOOD,
13¾IN X 10½IN (34.9CM X 26.7CM)
MICHIGAN, DETROIT INSTITUTE OF ARTS

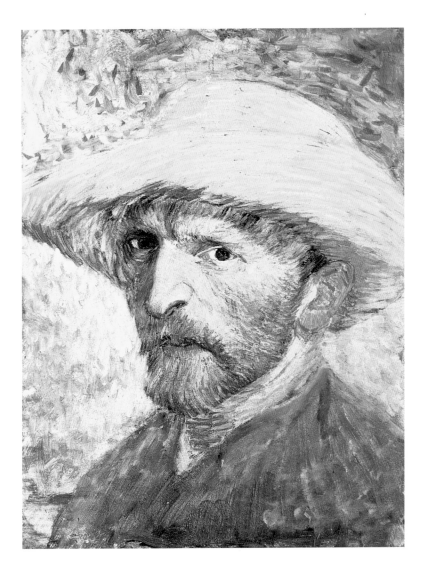

V AN GOGH IN HIS man-about-town guise wears a light felt hat, blue tie, overcoat, stiff collar, and what looks like a smart vest, piped in red. His eyes look intense and alert, even aggressive. The beard is trimly cut, with strong tinges of red.

Perhaps the most elaborate piece of painting is the overcoat, which is constructed of a mosaic of browns, greens, yellows, and blues. He has also taken great pains with the pupils of the eyes, which are translucent, and a convincing blueish-green. The full-front view suggests a degree of self-confidence.

"There are modern heads which people will go on looking at for a long time to come, and which perhaps they will mourn over after a hundred years . . ."

SELF-PORTRAIT
PARIS, SUMMER 1887
OIL ON CARDBOARD, 16½IN x 13⅜IN (42CM x 34CM)
AMSTERDAM, STEDELIJK MUSEUM

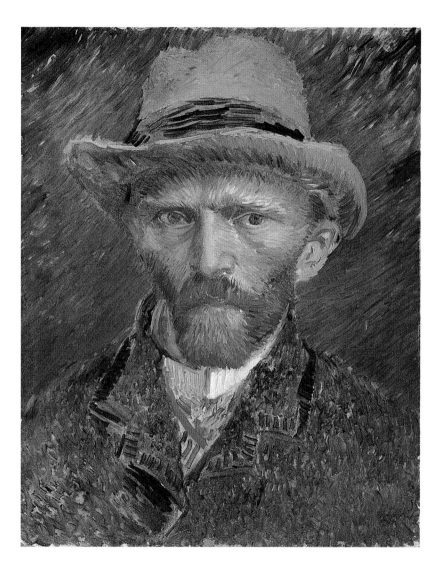

THE FIFTH OF VAN GOGH'S self-portraits in a straw hat, this shows very strongly the two influences that were deeply affecting him at this time. That of Monticelli, the Italian-born artist working in Marseilles, is apparent in the heavy impasto; and the influence of the Pointillists can be seen in the use of small brushstrokes, juxtaposed to build up form and express color.

"As for stippling [Pointillism], and making haloes, and other things, I think they are real discoveries, but we must see to it that this technique does not become a universal dogma more than any other."

The whole painting is composed of swirling vortices of adjacent and interspersed colors: cobalt blue, yellow, red, brown, and white. The eyes are fixed on some distant goal and have a mild air of melancholy.

SELF-PORTRAIT WITH STRAW HAT
PARIS, SUMMER 1887
OIL ON CANVAS, 16IN x 12½IN (40.6CM x 31.8CM)
NEW YORK, METROPOLITAN MUSEUM OF ART

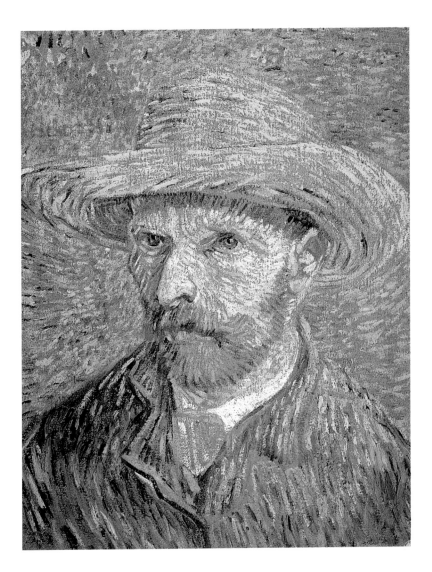

T HIS IS CLEARLY
an experimental work. Van Gogh tries out the
effect of painting the head and shoulders with a
high degree of observational precision, and then
scatters around them a shower of brushed dabs
of black. It gives credence to one of his deeply-
held beliefs:

*"The portrait, one can say of it that it is something
old, but it is also completely new . . . I always have hopes
that a fine revolution in portraiture is waiting for us."*

The dabs do not occupy the whole of the
background, but cascade over the head and
shoulders, and appear to land on the jacket. His
look suggests a degree of resolution, and
even contentment.

SELF-PORTRAIT
PARIS, SUMMER 1887
OIL ON CANVAS, 16⅛IN X 13IN (41CM X 33CM)
AMSTERDAM, VAN GOGH MUSEUM
VINCENT VAN GOGH FOUNDATION

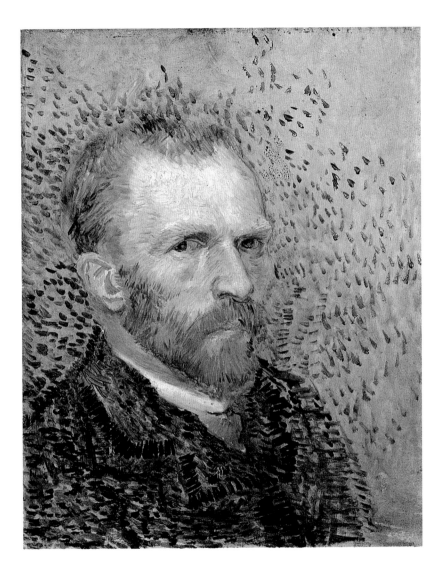

Vincent's projections of himself
vary a good deal, even in everyday life. Many of
his acquaintances commented on his smartness,
and A. S. Hartrick noted in his later autobiography,
"He dressed quite well, and better than many in
[Cormon's] atelier."

This is how van Gogh saw himself in this guise,
complete with suit, buttoned vest, stiff collar, and
the blue tie that always appears in his smart outfits.
His face radiates a degree of something
approaching equanimity, if not quite self-
confidence. This effect is enhanced by the
light coloring.

SELF-PORTRAIT
PARIS, SUMMER 1887
OIL ON PAPER, 13⅜IN X 9⅞IN (34CM X 25CM)
OTTERLO, RIJKSMUSEUM KRÖLLER-MÜLLER

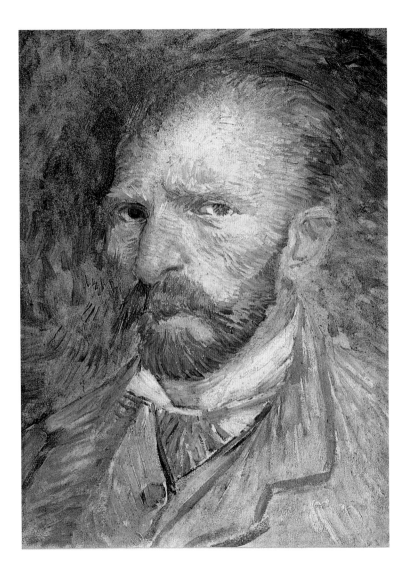

I T WAS IN HIS PARISIAN self-portraits, the majority of which were painted in Theo's apartment in the rue Lepic, that Vincent was able to experiment with the changes that were coming over his style.

This version shows how the initial impact of Impressionism has been overlaid by the influence of Seurat's compositional technique of building a picture out of small units of color. Instead of small precise units, however, Van Gogh uses innumerable horizontal and vertical brushstrokes that rain down on the canvas in a variety of colors. These create a flickering background out of which the face emerges with a dramatic intensity.

"I feel . . . that there is a power within me, and I do what I can to bring it out and free it."

SELF-PORTRAIT
PARIS, FALL 1887
OIL ON CANVAS, 18½IN X 14IN (47CM X 35.5CM)
ZURICH, E. G. BÜRHLE COLLECTION

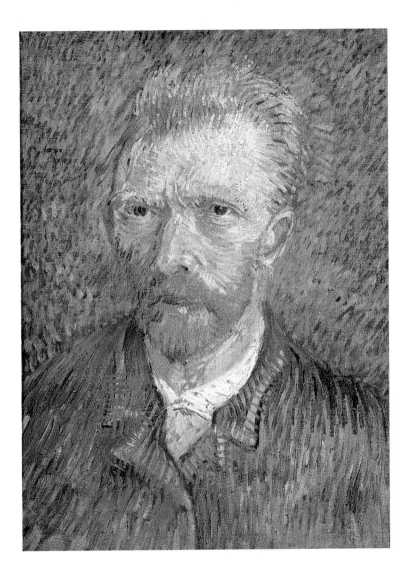

PAINTED AT A TIME when there was ill-feeling between Vincent and Theo, who was suffering from nervous tension and general poor health, this shows Vincent radiating a self-confidence that borders on aggressiveness. The same quality can be seen in the vigorous brushwork that radiates out from the center of his face. The emphatic, orange-red hair and beard infuse the skin of the face with their glow.

This coloring emphasizes an enigma about the whole series of self-portraits. Observers say that Vincent was red-haired (see page 105), but in several paintings his hair is mostly auburn (see pages 67, 71, and 77), and the painting on page 31, painted in the previous year, shows him with dark auburn hair and only a small amount of ginger in the beard.

Experts are divided as to whether certain van Gogh paintings are authentic. This self-portrait is seen as genuine by some, but is doubted by others. (See also pages 84 and 88.)

SELF-PORTRAIT
PARIS, 1887
OIL ON CANVAS, 18⅛IN X 14¹⁵⁄₁₆IN (46CM X 38CM)
VIENNA, ÖSTERREICHISCHE GALERIE

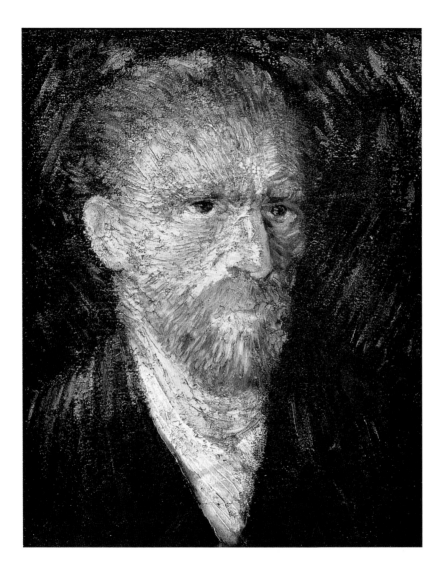

O NE OF VINCENT'S more curious self-portraits. From what looks like a tiled background, it was probably painted in the Café Tambourin, a famous restaurant and cabaret in the Boulevard Clichy. The same tiled background also appears in his portrait of Agostina Segatori, the proprietress (Amsterdam, Van Gogh Museum), and in Toulouse-Lautrec's portrait of van Gogh (see page 113).

In March 1887, Vincent persuaded the proprietress to let him stage an exhibition of Japanese prints in the café. This explains the roughly sketched, geisha-like figure drawn on the wall over his left shoulder. Van Gogh had developed an interest in Japanese art, partly due to the influence of his friends Russell and Toulouse-Lautrec; he wrote at the time,

". . . you cannot study Japanese art without becoming much gayer and happier . . ."

SELF-PORTRAIT WITH JAPANESE PRINT
PARIS, LATE 1887
OIL ON CANVAS, 16^{15}⁄$_{16}$IN X13^3⁄$_8$IN (43CM X 34CM)
BASEL, ÖFFENTLICHE KUNSTSAMMLUNG KUNSTMUSEUM

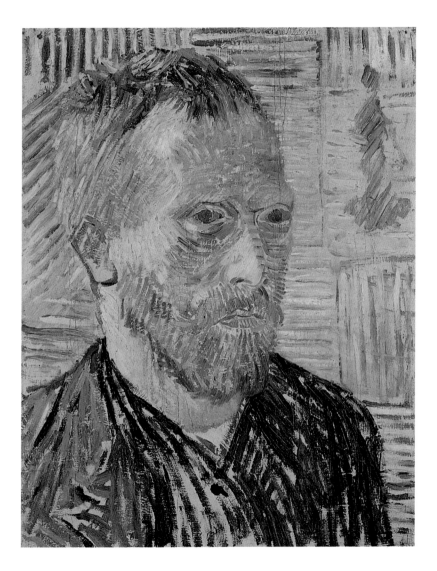

Although van Gogh is wearing the felt hat that also appears on pages 41 and 63, this portrait seems to have been painted late in 1887 or early in 1888. It shows a remarkable degree of development, both in the vigor and the independence of the brushwork, and in the increased dramatic intensity of the whole effect. He is dressed in a simple, buttoned shirt without a stiff collar and tie; the hat seems to have been jammed down more emphatically on his head, and his beard is a more provocative red.

Above all, this painting is more assertive than the earlier versions. In those, the reddish complexion is painted almost conventionally: it is smoothly textured and melds into the facial hair. In this version it is indicated by a vortex of thick blots of red, brown, blue, and white, that radiate out from the area around the bridge of the nose. The background, with flecks of red, brown, white, and orange, is swept up in the same strong pattern.

SELF-PORTRAIT IN A GRAY FELT HAT
PARIS, LATE 1887/EARLY 1888
OIL ON CANVAS, 17⁷⁄₁₆IN X 14¾IN (44CM X 37.5CM)
AMSTERDAM, VAN GOGH MUSEUM
VINCENT VAN GOGH FOUNDATION

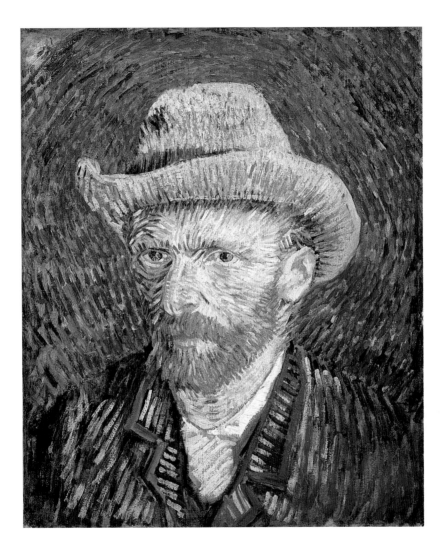

Oprah-trait NE OF THE MOST DRAMATIC
and studied self-portraits of his Paris period, this
version features van Gogh's presentation of
himself in conventional clothes, complete with bow
tie and stiff collar. It also displays the technical self-
confidence and vigor he had acquired over the
previous year.

The background is dark enough to appear
almost monochromatic. On closer inspection,
however, it is flecked with horizontal strokes of
blue, that appear to come from underpainting. The
suit is defined by vertical brushstrokes that cascade
over the canvas to define the form. The use of
white to define the area under the lobe of the ear is
a particularly effective touch.

SELF-PORTRAIT
PARIS, FALL/WINTER 1887
OIL ON CANVAS, 17⁵⁄₁₆IN X 13¾IN (44CM X 35CM)
PARIS, MUSÉE D'ORSAY

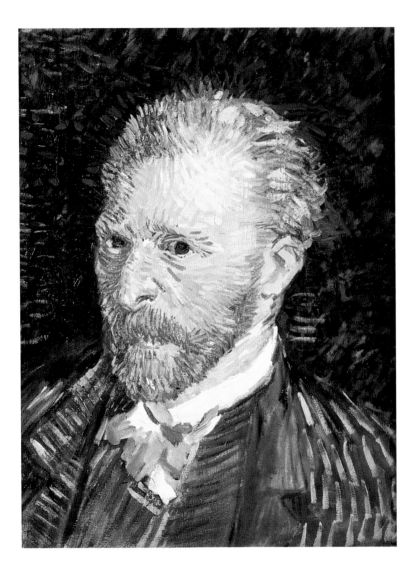

V

out of a strongly-lit background in a semi-theatrical light. The colors are applied with many small brushstrokes that reflect the techniques introduced by Seurat and Signac.

This was the last self-portrait Vincent painted in Paris. He himself saw it as *"the face of death,"* and he described it in a letter to Willemina later in 1888:

"Here I give a conception of mine, which is the result of a portrait I painted in the mirror. . . . A pinkish-gray face with green eyes, ash-colored hair, wrinkles on the forehead and around the mouth, stiff, wooden; a very red beard, neglected and mournful; but full lips, a blue peasant's blouse of coarse linen, and a palette with citron yellow, vermilion, malachite, cobalt blue, in short, all the colors on the palette, except the orange beard, but only whole colors."

Jo van Gogh-Bonger, Theo's widow, was later to say that it was "of all his self-portraits, the one with the most likeness."

SELF-PORTRAIT AT THE EASEL
PARIS, EARLY 1888
OIL ON CANVAS, 25¾IN X 19⅞IN (65.5CM X 50.5CM)
AMSTERDAM, VAN GOGH MUSEUM
VINCENT VAN GOGH FOUNDATION

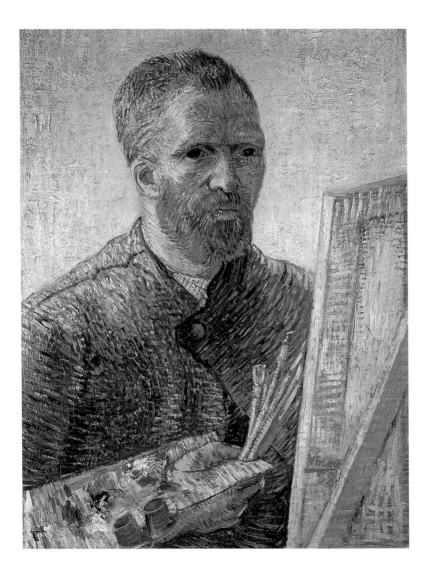

VINCENT PAINTED THIS shortly after his arrival in Arles, when he was full of enthusiasm for the joys of the south.

"I am convinced that I shall set my individuality free simply by staying on here."

He looks intent on identifying himself with the native Provençals: the straw hat, of the kind worn by the locals (and by his hero Monticelli), and the corncob pipe appear part of a quest for a new identity. He assumes a persona totally different from the Parisian van Gogh, with his tie and sober suits.

In Paris, Vincent's straw hat had been coaxed into a formal shape. Here it is turned down to shelter him from the radiance of the sun, that floods his face and the whole upper section of the picture. He superimposes the head, face, and hat onto an aquamarine foundation that continues to show through the upper background.

SELF-PORTRAIT WITH STRAW HAT AND PIPE
ARLES, SPRING 1888
OIL ON CANVAS ATTACHED TO BOARD, 16½IN X 11¹³⁄₁₆IN (42CM X 30CM)
AMSTERDAM, VAN GOGH MUSEUM
VINCENT VAN GOGH FOUNDATION

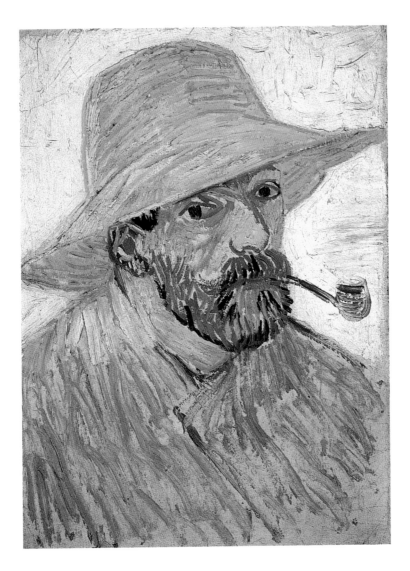

V AN GOGH SPENT THE EARLY
spring of 1888 getting to know Arles, and then
started exploring the southern countryside that
surrounded the town. On excursions like this one
to Tarascon, midway between Arles and Avignon,
Vincent appeared, as he wrote to Willemina,

". . . always very dusty, always bristlingly loaded,
like a porcupine, with sticks, an easel, canvases, and
other merchandise."

The clear landscape, with its ordered
composition, illustrates an aspect of Provence on
which he commented in the same letter,

"What strikes me here, and what makes painting so
attractive, is the clearness of the air. . . . In our country
we see a vague gray on the horizon; here, even in the
far, far distance the line is sharply defined, and its
shape is clearly definable. This gives one an idea of air
and space."

(See also page 72, for the modern debate on
authenticity, and page 125.)

(See also page 72, for the modern debate on authenticity, and page 125.)

THE ARTIST ON THE ROAD TO TARASCON
ARLES, AUGUST 1888
OIL ON CANVAS, 18⅞IN X 17⁵⁄₁₆IN (48CM X 44CM)
ORIGINALLY IN THE KAISER FRIEDRICH MUSEUM, MAGDEBURG, THIS
WAS MOVED WITH OTHER ART TREASURES TO THE SALT MINES AT
NEUSTASSFURT IN 1942, AND WAS DESTROYED BY FIRE IN 1945.

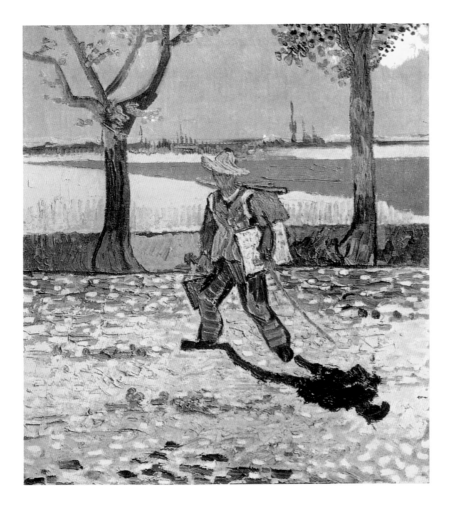

WHEN HE PAINTED THIS portrait, van Gogh was in an agony of apprehension as to whether or not Gauguin, who was then at Pont-Aven in Brittany, would come to join him at Arles. It is therefore possible that Vincent was influenced in his approach by a desire to produce a work which Gauguin would like. It shows a van Gogh very different from most of the earlier portraits: his beard is savagely trimmed, his head is virtually shaven, and the whole impression is almost icon-like in its severity. In a letter to Theo he described the painting as

". . . all ashen gray against pale malachite (no yellow). The clothes are this brown coat with a blue border, but I have exaggerated the brown into purple, and the width of the blue borders. The head is modeled in light colors painted in thick impasto against the light background, with hardly any shadows. Only I have made the eyes slightly slanting, like the Japanese."

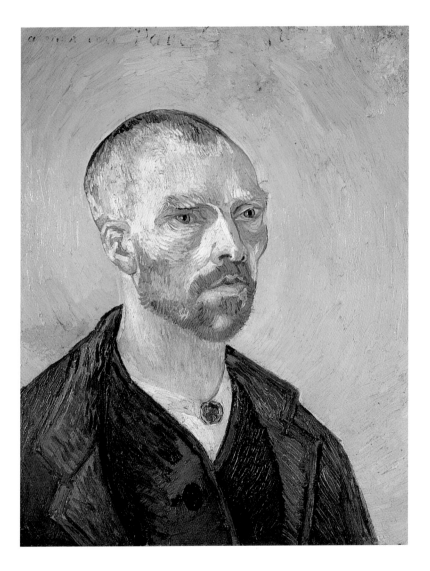

I N TERMS OF COMPOSITION and concept, this is the most remarkable of all van Gogh's self-portraits. The halo-like effect is very emphatic, and the surrounding golden background suggests a well-ordered mosaic, rather than the more spontaneous brushstrokes that he usually employed in this context. Even the proportions of the canvas are unusual for Vincent, but he shows his preference for a more standard size by leaving the lower part largely unpainted, except for the addition of part of a Japanese print depicting the head of a *samurai* warrior.

The inscription on the painting, *"étude à la bougie"* ("study by candlelight"), reflects van Gogh's preoccupation with this form of lighting, inspired by Monticelli, who frequently painted by candlelight. Vincent even experimented with nighttime painting using candles stuck in his hat.

(As with the paintings on pages 73 and 85, there is disagreement among experts as to this self-portrait's authenticity.)

SELF-PORTRAIT BY CANDLELIGHT
INSCRIBED "ÉTUDE À LA BOUGIE"
ARLES, SEPTEMBER 1888
OIL ON CANVAS, 24⅜IN X 20½IN (62CM X 52CM)
PRIVATE COLLECTION

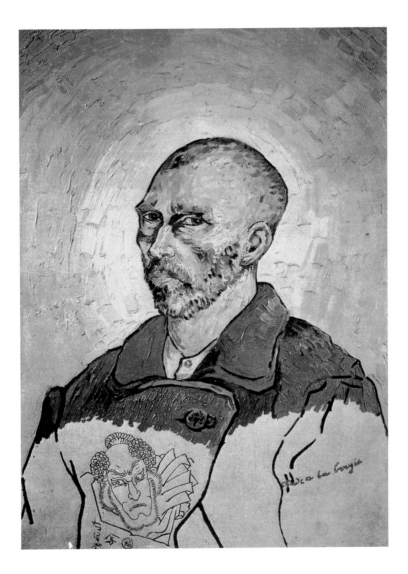

CHARLES LAVAL, who had been working at Pont-Aven with Gauguin and others, was one of the first to respond to van Gogh's plan for exchanging self-portraits with fellow-artists. (Vincent mistakenly thought this was the custom in the Japanese art world.) Van Gogh told Theo he was delighted with Laval's work (now in Amsterdam, at the Van Gogh Museum), and painted this one in return.

It is in strong contrast to the portrait that Vincent had done for Gauguin (see page 87): yellows and greens dominate, the painting is meticulously correct, and the complexion of the skin is painted with almost academic realism. His eyes indicate a considerable degree of relaxation, his hair has been allowed to grow, and it is carefully brushed and parted. Gauguin was supposed to have taken the painting back to Laval, but did not do so, and it was forwarded to Theo instead.

SELF-PORTRAIT
INSCRIBED *"À L'AMI LAVAL"*
ARLES, DECEMBER 1888
OIL ON CANVAS, 18⅛IN X 15IN (46CM X 38CM)
NEW YORK, PRIVATE COLLECTION

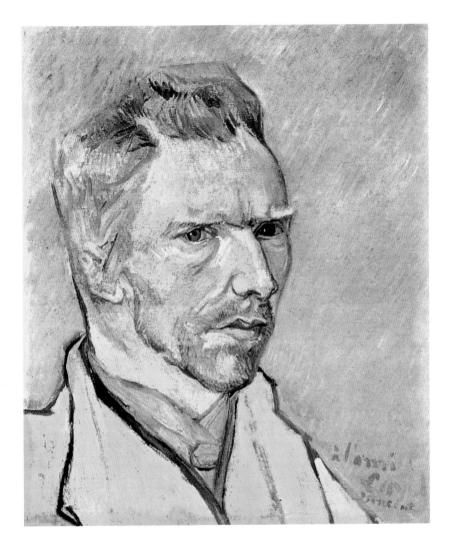

W HEN HE WAS
released from hospital after cutting off part of his ear, Vincent started painting again and noted that he was *"very obviously looking better."* It was presumably to prove his point that he sent Theo this, one of his most striking and ingeniously contrived self-portraits.

The location is Vincent's bedroom, and he is looking into the mirror that hung in the right corner beside the window, part of which appears on the right-hand side of the canvas. Hanging behind him is a Japanese print showing Mount Fuji in the distance and a group of women in the foreground. Also behind him is an easel with a roughly drawn outline on the canvas that it supports. Van Gogh painted his reflection directly in the mirror, so his right ear appears bandaged. In reality the left was the injured one. Although he is haggard, there is no disquiet in his eyes.

SELF-PORTRAIT WITH A BANDAGED EAR
ARLES, JANUARY 1889
OIL ON CANVAS, 23⅝IN X 19¼IN (60CM X 49CM)
LONDON, COURTAULD INSTITUTE GALLERIES

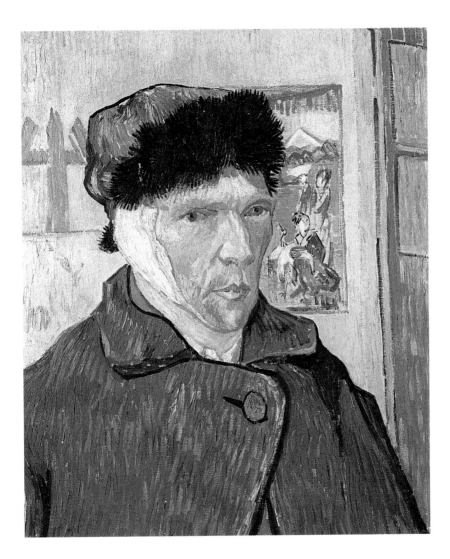

PAINTED ABOUT THE SAME TIME as the previous portrait, this is clearly part of the process by which van Gogh was looking to reassure both himself and Theo that he had really recovered.

"I am inclined to believe that the portrait can tell you better than the letter how things are going with me."

It is a remarkable exercise in chromatic gradations. The red, yellow, and orange background, the blueish-black fur hat, the yellow, rococo swirls of smoke rising from his pipe, and the mélange of greens, whites, and yellows which form the lower two-thirds of the picture, have a controlled vivacity which could hardly have represented his real feelings at the time. Within weeks of painting this picture Vincent began to think that people were poisoning him, and on February 7, 1889, he was taken back to hospital and put in an isolation cell.

SELF-PORTRAIT WITH PIPE
ARLES, JANUARY 1889
OIL ON CANVAS, 20⅛IN X 17¾IN (51CM X 45CM)
LONDON, PRIVATE COLLECTION

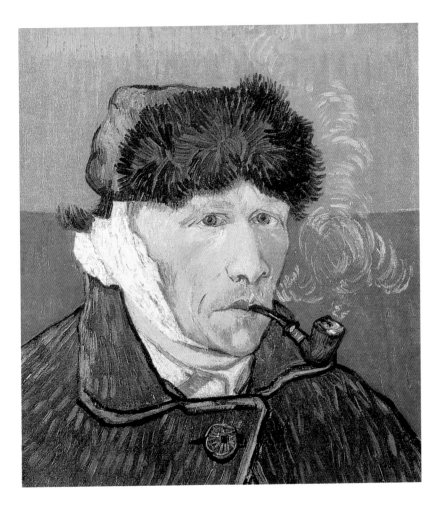

VINCENT PAINTED THIS self-portrait in the asylum at Saint-Rémy, where he had recently tried to commit suicide by swallowing some of his paints. He probably made this painting and that on page 101 to assure Théophile Peyron, the doctor in charge of the asylum, that he had completely recovered. His face certainly seems placid enough. The brushwork, with its flame-like flickering in the background and its heavy swirling emphasis in the blue smock he wears, has been interpreted as the "calligraphy of psychosis." In a letter to Theo at this time, Vincent wrote,

"I must do better than before . . . and you will see this when you put the portrait I have just finished next to the self-portraits in Paris, and I look saner now than I did then, even more so. I am even inclined to think . . . that it will reassure you – it cost me some trouble to do. The desire I have to make portraits now is terribly intense."

SELF-PORTRAIT WITH PALETTE
SAINT-RÉMY, AUGUST-SEPTEMBER 1889
OIL ON CANVAS, 22⁷/₁₆IN X 17⅛IN (57CM X 43.5CM)
NEW YORK, COLLECTION OF MRS. JOHN HAY WHITNEY

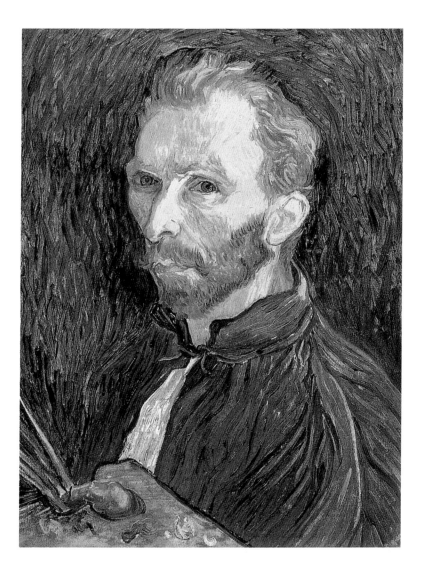

PAINTED IN SAINT-RÉMY
at a time when van Gogh was becoming
increasingly irritated by the asylum, this portrait
reveals, more than any of the others he made there,
something of the melancholy, if not despair, that
must have sometimes overcome him.

*"I have talked to M. Peyron [the asylum doctor]
about the situation, and I told him that it was almost
impossible for me to endure my lot here."*

It is not so much the actual appearance of the
face that suggests his misery, as the general
tonality of the work. The heavy impasto, with its
echoes of Rembrandt, and the swirling, flame-like
background in turquoise, yellow, and black, hint at
a soul trapped in some personal Hades. However,
the look on Vincent's face is neither "mad"
nor plaintive; "quizzical" is the closest
verbal equivalent.

SELF-PORTRAIT
SAINT-RÉMY, AUGUST-SEPTEMBER 1889
OIL ON CANVAS, 20¹⁄₁₆IN x 17¾IN (51CM x 45CM)
OSLO, NASJONALGALLERIET

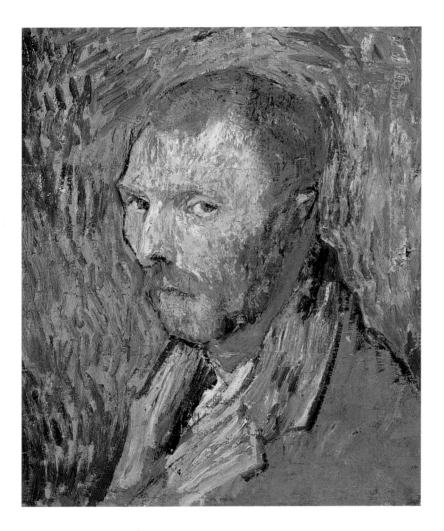

V

INCENT PAINTED THIS portrait before he left Saint-Rémy to stay for a short time in Paris with Theo. He then went to Auvers, where he was looked after – in a vague sort of way – by Dr. Paul Gachet. He was very anxious that the doctor should see this work, and later claimed that Gachet was *"absolutely fanatical"* about it. The painting stayed in the Gachet household, and was given to the Louvre in 1949.

It is dominated by the familiar background of spirals, repeated with cobalt additions in the jacket and vest; these are a perfect foil for the face and head, which have an emphatic three-dimensional quality. The whole composition revolves around the intensely red beard, emphasized by the triangular white of the buttoned shirt.

SELF-PORTRAIT
SAINT-RÉMY, SEPTEMBER 1889
OIL ON CANVAS, 25⅝IN X 21⁷⁄₁₆IN (65CM X 54.5CM)
PARIS, MUSÉE D'ORSAY

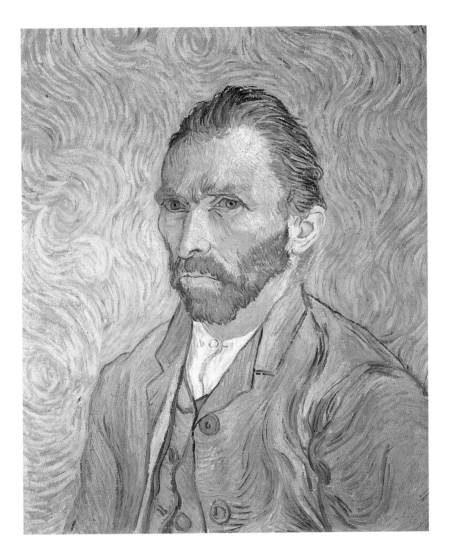

I T IS A SAD AND IRONIC FACT
that what is the last self-portrait that van Gogh
painted was a lie. Early in 1889 his mother
celebrated her seventieth birthday. Although they
had not been in constant contact, Vincent still
cherished the warmest memories of her, and they
kept up an irregular correspondence.

Later in the year he decided to send her this
self-portrait, mainly to reassure her about his
health. Van Gogh painted himself not as he then
was, but as a much younger and healthier-looking
man: clean-shaven, with well-brushed hair and a
proper painter's smock. He was, however, unable
to avoid the look of desperation that hovers over
his features. He later sent his mother a version of
the painting of his bedroom in Arles; this painting
and one of his sister Willemina are shown hanging
on the wall.

SELF-PORTRAIT
SAINT-RÉMY, SEPTEMBER 1889
OIL ON CANVAS, 15¾IN X 12¼IN (40CM X 31CM)
SWITZERLAND, PRIVATE COLLECTION

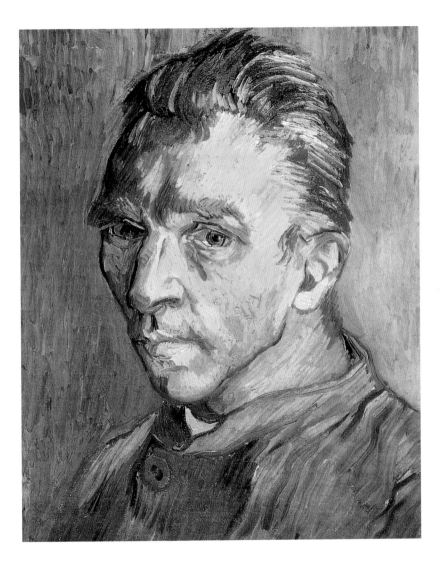

In the Eyes of Others

One of van Gogh's many preoccupations was that of a select group of artists cementing their relationship with each other by exchanging portraits. This project never got very far, but it did stimulate a number of his friends to make portraits of him; these are presented in the following pages. However, no portrait or self-portrait can adequately depict what a person looks like in the context of his life and the eyes of others, nor explain his impact on his contemporaries, and those of van Gogh need support from the written words of those who knew him.

One consistent element that appears in descriptions of him is his small stature. Piet Kaufman, his father's youthful gardener at the parsonage in Essen, set the tone when he wrote: "He always walked lost in thought; he never recognized anybody in the street; he was a queer little fellow."

Gestel Dimmen, one of his "students" in Nuenen, described him as "a short, square, little man, called by the rustics *'het schildermanneke'* – 'the little painter chap.' His sunburned, weatherbeaten face was framed by a reddish, stubbly beard. His eyes were inflamed, partly from working in the sun. Had it not been Sunday he would have

been wearing his blue blouse, but as it was he was dressed in a short, thick donkey jacket, the kind bargemen generally wear."

All those who met van Gogh spoke about his general air of unrestrained vivacity. Here is his fellow student Victor Hageman describing Vincent's arrival at the Antwerp Academy of Art in November 1885, "I remember well that weatherbeaten, nervous, restless man who crashed like a bombshell into the Academy, upsetting the director, the drawing master, and the students. One morning van Gogh came into the class dressed in a kind of blue blouse of the kind usually worn by Flemish cattle dealers. He had a fur cap on his head. Instead of a palette he used a rough board torn from a packing case."

A. S. Hartrick, the painter and engraver who met van Gogh at Cormon's studio in Paris in 1886, gave a lively account of Vincent's physical characteristics and mannerisms, at a fifty-year distance. ". . . to my eye van Gogh was a rather weedy little man, with pinched features, red hair, and light blue eyes. He had an extraordinary way of pouring out sentences, if he got started, in Dutch, English, and French, then glancing back at you over his shoulder,

and hissing through his teeth. In fact, when thus excited, he looked more than a little mad; at other times he was apt to be morose, as if suspicious."

Paul Signac, walking down the street in Paris with Vincent one day, noted that "Van Gogh, dressed in a blue workman's blouse, had little dashes of color splashed all over his sleeves. Sticking close to me, he shouted and gesticulated, brandishing his freshly painted canvas and showering paint all over himself and passers-by." And when van Gogh first met Camille Pissarro, he arranged his canvases along a wall in the street to show them to the older man.

Even the long-suffering Theo sometimes found Vincent hard to take. Theo wrote to their sister Willemina in 1887, when the brothers were sharing an apartment, "My home life is unbearable. Nobody wants to come and see me any more because it always ends in quarrels, and besides, he is untidy, his room always looks so unattractive. I wish he would go and live by himself. . . . It seems as if he were two persons: one marvelously gifted, tender, and refined; the other egotistic and hard-hearted. They present themselves in turns, so that one hears him talk first in one way, then in the other, and always with arguments on both sides. It is a pity he is his own enemy, for he makes life hard, not only for others, but for himself."

Van Gogh's officer friend in Arles, Paul-Eugène Milliet, described how these different characteristics spilled over into his painting activities: "A pleasant chap when he was in a good mood, which was not always the case. Sometimes when he put up his easel and began to splash about, it didn't go well, and this young man with a taste and talent for drawing became a fanatic as soon as he laid hands on a paintbrush. When he started painting I always walked away, or if I stayed, refused to pass an opinion, otherwise we nearly came to blows. He had a complex character, and when he got angry he seemed to lose his reason. . . . A canvas should be approached gently, but van Gogh assaulted it. Sometimes he was a real beast, a ruffian. He was excessively sensitive, sometimes reacting like a woman. . . . All in all a good pal, not a bad chap."

To Emile Bernard, Vincent was "the most noble man one could think of, free and open, extremely lively, and with a certain droll, mischievous sting."

However, the most recent comment by someone who had known Vincent was not so flattering. At a big van Gogh celebration in Arles in 1989, Mme. Jeanne Calment, then 114 years old, was asked if she remembered van Gogh; she replied that she did, as he used to come into her father's shop to buy canvases. "He was horrible," she added, "always rude and upsetting people."

DURING THE SHORT PERIOD in late 1885 and early 1886 when he studied at the Antwerp Academy, van Gogh became friendly with Horace Livens (also known as Lievens), a young Englishman who had moved to Antwerp from the Croydon School of Art. The watercolor reproduced here is probably based on a portrait Livens painted of Vincent, and it shows van Gogh looking a good deal older than he actually was. Livens later had a moderately successful career in London, painting Impressionistic pictures.

PORTRAIT OF VAN GOGH
HORACE M. LIVENS (LIEVENS), ANTWERP, 1885-6
LITHOGRAPH COPY OF A WATERCOLOR
PUBLISHED IN THE DUTCH MAGAZINE
VAN NU EN STRAKS (TODAY AND TOMORROW) IN 1895
THE ORIGINAL WATERCOLOR WAS LOST OR DESTROYED.

ALTHOUGH VAN GOGH stayed only a short time at Cormon's studio, the experience enlarged his horizons and brought him into contact with a wider range of acquaintances. These included Toulouse-Lautrec, Emile Bernard, and John Peter Russell, an Australian, with whom he was to remain in contact for the rest of his life.

Russell painted this striking portrait in his studio in the Impasse Hélène, off the Boulevard de Clichy, where he kept an impressive collection of Japanese prints that he had brought with him from Australia.

VINCENT VAN GOGH
JOHN PETER RUSSELL, PARIS, 1886
OIL ON CANVAS, 23⅜IN X 17¾IN (60CM X 45CM)
AMSTERDAM, VAN GOGH MUSEUM
VINCENT VAN GOGH FOUNDATION

V AN GOGH FIRST MET
Toulouse-Lautrec at Cormon's atelier in Paris, and,
together with Emile Bernard, they spent a lot of
time in the cabarets and brasseries of Montmartre.
They also exchanged pictures: Vincent gave
Lautrec a view of the roofs of Paris, which Lautrec
hung in his studio in the rue Tourlaque.

This portrait, with its fragmentation of
brushstrokes reminiscent of the technique of
Seurat, and its emphatic yellows and blues, was
painted in Le Tambourin, a café where the pair
often went (see pages 75 and 142). The dramatic
lighting and van Gogh's posture emphasize his
sense of dedication.

VINCENT VAN GOGH
HENRI DE TOULOUSE-LAUTREC, PARIS, 1887
PASTEL AND WATERCOLOR ON PAPER, 21¼IN X 18⅛IN (54CM X 46CM)
AMSTERDAM, VAN GOGH MUSEUM
VINCENT VAN GOGH FOUNDATION

T HIS PORTRAIT
was painted shortly after Gauguin's arrival at
Arles. He had painted his own portrait in Pont-
Aven, and brought it with him to Arles, explaining
its symbolism to Vincent – yellow for the purity of
the Impressionist artist, the glow of the flesh for
creativity. The same significance was presumably
attached to this portrait of van Gogh.

Gauguin's own account of the painting was
given later. "While he was painting a still life,
Sunflowers, which he loved so much, the thought
came to me that I should paint him. When the
portrait was finished he said to me, 'Yes, that is me,
but as a madman.'"

VAN GOGH PAINTING SUNFLOWERS
PAUL GAUGUIN, ARLES, NOVEMBER 1888
OIL ON CANVAS, 28¾IN X 35¹³⁄₁₆IN (73CM X 91CM)
AMSTERDAM, VAN GOGH MUSEUM
VINCENT VAN GOGH FOUNDATION

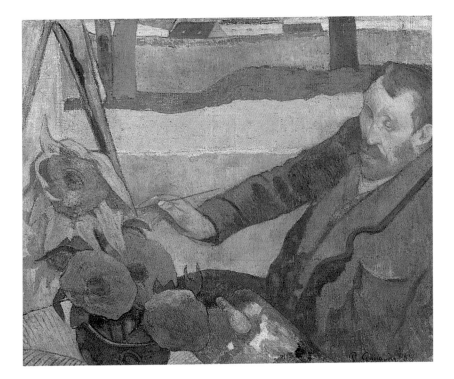

VAN GOGH FIRST MET
Lucien Pissarro with his father Camille. They seem
to have got on very well together, and Vincent
dedicated and signed a still life for Lucien. The
smartly-dressed Félix Fénéon was one of the most
brilliant and witty art critics of his time, and was a
frequent contributor to the periodical *Les Hommes
d'Aujourd'hui* (see page 120). Vincent is wearing the
gray felt hat which appears in many of his
Parisian self-portraits.

VINCENT IN CONVERSATION WITH FÉLIX FÉNÉON
LUCIEN PISSARRO, PARIS, C.1888
BLACK CRAYON ON PAPER, 8⅝IN X 6¹¹⁄₁₆IN (22CM X 17CM)
OXFORD, ASHMOLEAN MUSEUM

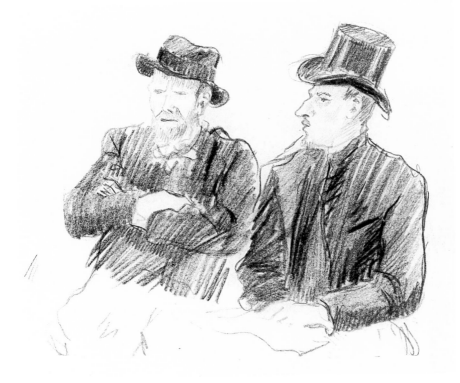

S SOON AS HE HEARD that Vincent had died, Dr. Gachet went to the inn of Arthur-Gustave Ravoux, where van Gogh had been staying. After Gachet drew this sketch, he, Ravoux, and Theo van Gogh, who had come up from Paris to be with his dying brother, then went to the town hall to register the death.

The drawing is dedicated to Theo van Gogh, and is signed PVR. (Gachet used the name Paul van Ryssel, derived from his birthplace near Lille, for his art work.) As well as making this sketch, Gachet also gave a moving oration over Vincent's grave at the funeral the following day.

VAN GOGH ON HIS DEATHBED
INSCRIBED *"29 JUILLET"*
PAUL GACHET, AUVERS, JULY 29, 1890
CHARCOAL ON PAPER, 10¾IN X 9IN (27.3CM X 22.8CM)
AMSTERDAM, VAN GOGH MUSEUM
VINCENT VAN GOGH FOUNDATION

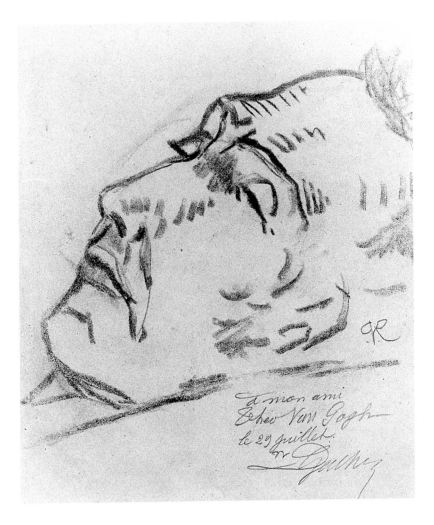

à mon ami
Théo Van Gogh
le 29 juillet.
Dr Gachet

E ACH ISSUE OF THE avant-garde, Parisian periodical *Les Hommes d'Aujourd'hui*, which flourished in the last decade of the nineteenth century, featured a contemporary writer, artist, or musician. Emile Bernard's lithograph of his friend has a note reading, *"d'aprés un portrait fait par lui"* ("after a self-portrait"): it is based on the painting shown on page 61. It appeared in an 1892 issue of the periodical, to coincide with the posthumous exhibition of Vincent's works, inspired by Theo van Gogh and organized by Bernard.

VINCENT VAN GOGH
EMILE BERNARD, PARIS, 1892
LITHOGRAPH FOR THE COVER OF
LES HOMMES D'AUJOURD'HUI
THE ORIGINAL LITHOGRAPH WAS LOST OR DESTROYED.

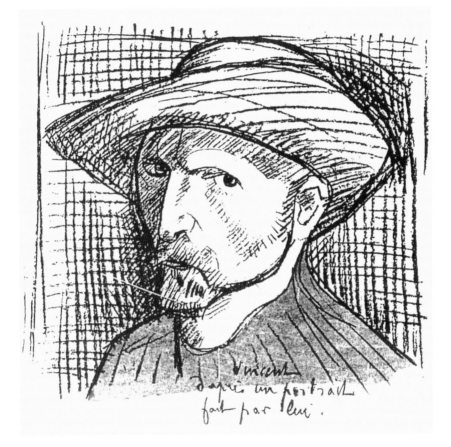

Vincent
d'après un portrait
fait par lui.

WHEN A. S. HARTRICK published *A Painter's Pilgrimage through Fifty Years* in 1939 (see Bibliography), he used this watercolor portrait of van Gogh as a frontispiece. The complete inscription runs, "A memory of Vincent van Gogh looking over his shoulder and hissing through his teeth *'bleu-crayon'*" (the last word is obscured).

Although signed with the artist's initials, the work is undated. The quotation comes from Chapter IV in the book, which deals with Hartrick's memories of Vincent (see page 105). Judging by the calligraphy, the work was not painted when the two were in contact; it was therefore probably painted specifically for the book. The portrait appears to be based partly on recollection – Hartrick was seventy-five when the book was published – and partly on elements in Vincent's own self-portraits.

VINCENT VAN GOGH
INSCRIBED "A MEMORY OF VINCENT VAN GOGH"
A. S. HARTRICK, LONDON, C.1939
WATERCOLOR
THE ORIGINAL WATERCOLOR WAS LOST OR DESTROYED.

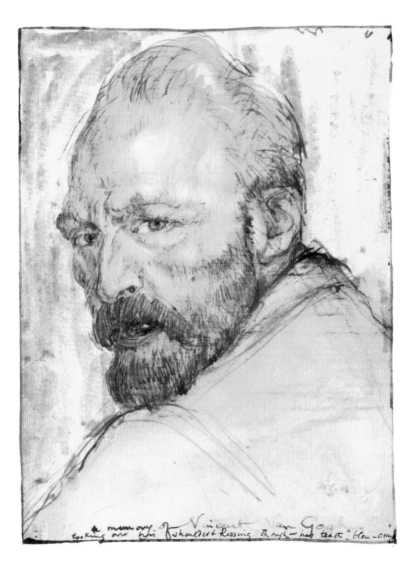

A memory of Vincent Van Gogh
looking over his shoulder + kissing though — his teeth "blu-orn"

F RANCIS BACON'S
international fame rests largely on his series of paintings based on the portrait of Pope Innocent X by Velasquez. Less well-known, however, is the series of eight paintings inspired by van Gogh's self-portrait, *The Artist on the Road to Tarascon* (see page 85), which were painted between 1956 and 1957. The original had been destroyed during the Second World War, so Bacon relied on reproductions. The studies were intended partly as a homage to van Gogh, and partly as an expression of Bacon's own disquiet and anguish. In this version the figure of van Gogh is much more stooped than in the original, and instead of looking at the spectator, he is staring down – like a "phantom of the road," as Bacon described it.

STUDY FOR A PORTRAIT OF VAN GOGH **IV**
FRANCIS BACON, LONDON, 1957
OIL ON CANVAS, 60IN X 45⅝IN (152.4CM X 115.8CM)
LONDON, TATE GALLERY

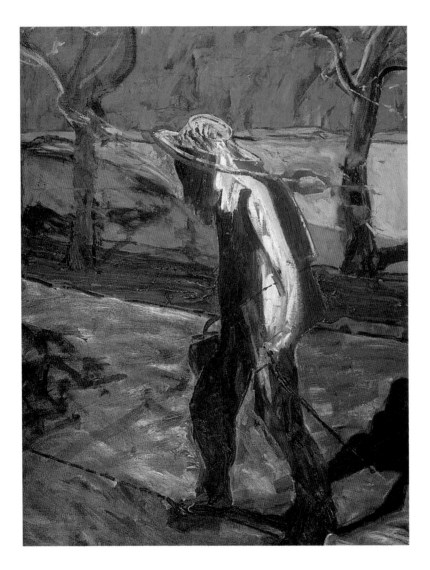

THE VAN GOGH FAMILY TREE

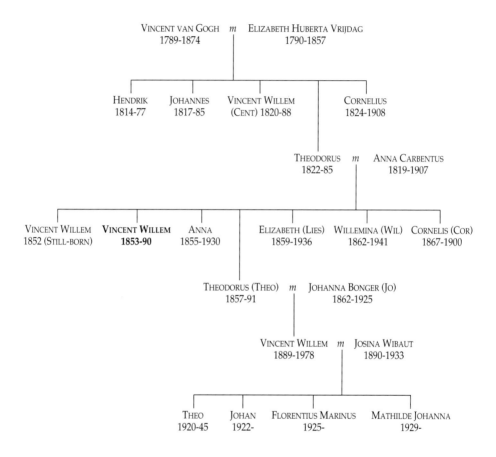

VINCENT VAN GOGH *m* ELIZABETH HUBERTA VRIJDAG
1789-1874 1790-1857

HENDRIK JOHANNES VINCENT WILLEM CORNELIUS
1814-77 1817-85 (CENT) 1820-88 1824-1908

THEODORUS *m* ANNA CARBENTUS
1822-85 1819-1907

VINCENT WILLEM **VINCENT WILLEM** ANNA ELIZABETH (LIES) WILLEMINA (WIL) CORNELIS (COR)
1852 (STILL-BORN) **1853-90** 1855-1930 1859-1936 1862-1941 1867-1900

THEODORUS (THEO) *m* JOHANNA BONGER (JO)
1857-91 1862-1925

VINCENT WILLEM *m* JOSINA WIBAUT
1889-1978 1890-1933

THEO JOHAN FLORENTIUS MARINUS MATHILDE JOHANNA
1920-45 1922- 1925- 1929-

This has been simplified for reasons of space. It does not include
all the many van Gogh and Carbentus relatives, among whom
were Anton Mauve and Cornelia Vos (see page 16).

THE VAN GOGH FAMILY

It would be difficult to imagine a more conventional family background than that which produced one of the most unconventional artists of all time. The van Goghs had been based in The Hague for a considerable time. Devout adherents of the Dutch Reformed Church – a strict Protestant sect – they had shown a tendency to become clergymen. Both Vincent's grandfather, after whom he was named, and his father were pastors. Vincent wrote to Theo,

"In our family, which is a Christian family in every sense, there has always been, from generation to generation, one who preached the Gospel."

It was as respectable a Dutch family as could be found anywhere, which makes the life and behavior of its most famous member even more unusual.

Vincent's relationships with his mother, father, Theo, and Willemina are described in this section. In his youth, Vincent was close to his eldest sister, Anna, and even walked over 100 miles to visit her when they were both working in England. But as Vincent became more eccentric, the relationship cooled; it ended when Vincent went to live at Nuenen.

Elizabeth published her memoirs of her eldest brother in 1913, but neither she, nor the youngest brother, Cornelis, were ever close to Vincent.

ANNA CORNELIA CARBENTUS was born in 1819 into a middle-class family from The Hague. In 1850 her sister married Vincent van Gogh (Uncle Cent), the older brother of Theodorus, whom Anna married a year later. Deeply committed to her family, she was a keen amateur artist and supported her eldest son's artistic ambitions. Vincent was very fond of her: when she broke her leg at Nuenen in 1884 he diligently looked after her. He painted this portrait of her, based on a photograph, in October 1888; he said he was doing it for himself, and added,

"I cannot stand the colorless photograph, and I am trying to do one of her in harmony of color as I see it in my memory."

In 1889 Vincent sent her a portrait of himself looking rejuvenated (see page 103). She died in January 1907, having lost all her sons: Vincent, Theo, and Cornelis, who died in 1900, possibly by his own hand.

PORTRAIT OF THE ARTIST'S MOTHER
ARLES, OCTOBER 1888
OIL ON CANVAS, 15^{15}/$_{16}$IN X 12^{3}/$_{4}$IN (40.5CM X 32.5CM)
LONDON, CHRISTIE'S

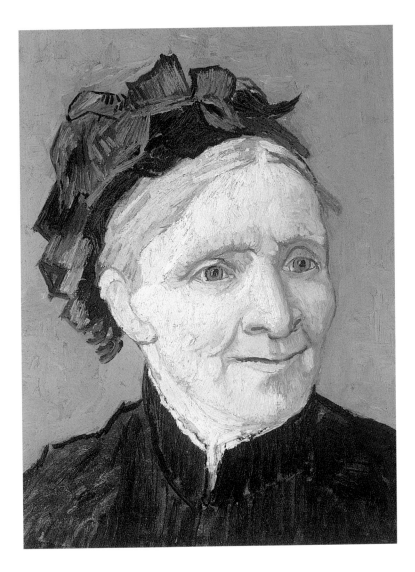

THEODORUS VAN GOGH was born in 1822, the son of a clergyman in the Dutch Reformed Church, Vincent van Gogh, who originated from The Hague. Theodorus followed his father into the church, and was appointed to a living in the predominantly Catholic village of Zundert, in Brabant. In 1851, he married Anna Cornelia Carbentus, by whom he had seven children, the first of whom, called Vincent, was stillborn. In 1871, Theodorus was posted to the parish of Helvoirt, where the stipend was better, and later moved to Nuenen, a smaller parish nearby. A kindly, diffident man, he was more tolerant of Vincent's eccentricities than might have been expected. He died of a heart attack on March 26, 1885.

THE ARTIST'S FATHER
ETTEN, JULY 1881
WASHED PEN AND INK, 13IN X 9⅞IN (33CM X 25CM)
THE HAGUE, NOVA SPECTRA GALERIE

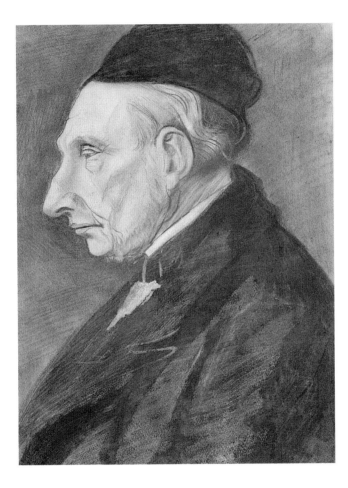

T HEO VAN GOGH was born in 1857. He joined the art firm of Goupil, Boussod et Valadon in 1878, eventually managing their Montmartre branch, where he pursued a policy of buying Impressionist works. Theo married Johanna Bonger, the sister of his old friend Andries, on December 24, 1888, and in 1889, they had a son, named Vincent Willem after his uncle.

Theo was in constant touch with Vincent, and arrived in Auvers in time to hold him as he died. Afterwards, Theo wrote their mother a letter which ended, "It is a grief that will last and which I shall never forget as long as I live. . . . Oh mother, he was my own, own brother."

Anxious to perpetuate Vincent's memory and ensure the survival of his works, Theo persuaded the possible heirs to Vincent's paintings to assign the estate to him. However, within a few months of Vincent's death Theo developed a kidney disease. This was soon followed by the onset of schizophrenia, and he died on January 25, 1891.

THEO VAN GOGH
(1857-91)
VINCENT'S BROTHER
AMSTERDAM, VAN GOGH MUSEUM
VINCENT VAN GOGH FOUNDATION

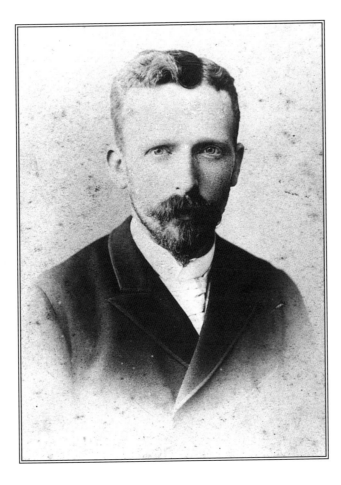

U

NCLE CENT
(Vincent Willem van Gogh) was born in 1820. The wealthiest of Vincent's many uncles, he was originally regarded by the family as Vincent's patron, primarily because he had no children of his own. An art dealer in Princenhage near The Hague, Uncle Cent specialized in the then very fashionable, contemporary Dutch painting. He worked in partnership with the Goupil brothers, French art dealers who had branches in The Hague, London, Brussels, and New York, and found jobs there for both Vincent and Theo.

When Vincent returned from England in 1876, Uncle Cent secured employment for him in a bookshop in Dordrecht. Vincent held the job for only a few weeks. After that the uncle gave up all hope of that particular nephew, and concentrated his benevolence on Theo, to whom he left a considerable inheritance on his death in 1888.

VINCENT WILLEM VAN GOGH (UNCLE CENT)
(1820-88)
VINCENT'S UNCLE
AMSTERDAM, VAN GOGH MUSEUM
VINCENT VAN GOGH FOUNDATION

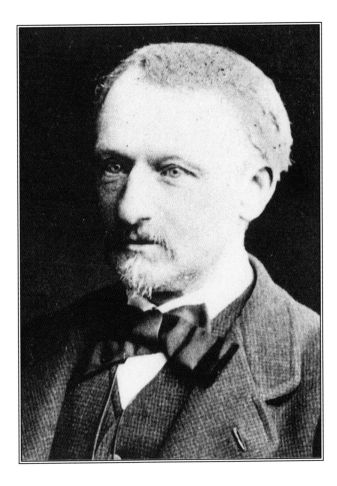

ILLEMINA VAN GOGH was born in 1862. During his early attempts at directly painting the human figure, Vincent used his youngest sister as a model. A number of his pictures of peasants are based on Willemina, as she sat at a sewing machine.

Some of Vincent's most interesting letters were written to Willemina; her portrait is on the wall in the picture of his bedroom, that Vincent sent to their mother from Arles. Some years after Vincent's death, Willemina had a complete mental breakdown, and was interred in an asylum in Holland until her death in 1941, at the age of seventy-nine.

WILLEMINA VAN GOGH (WIL)
(1862-1941)
VINCENT'S SISTER
AMSTERDAM, VAN GOGH MUSEUM
VINCENT VAN GOGH FOUNDATION

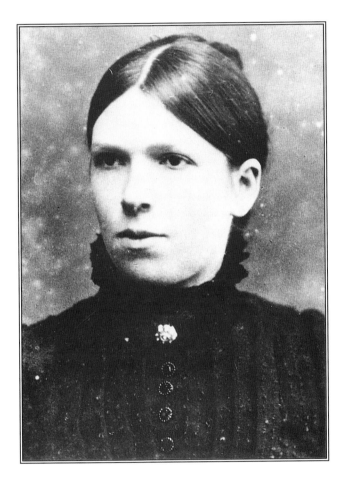

POSTSCRIPT

After Theo van Gogh's death, his widow, Johanna, devoted herself to publicizing Vincent's life and works. She edited the 600 letters and notes he wrote, and first published them in Dutch, in three volumes, in 1914. Between 1916 and 1919 she lived in America with her son, Vincent Willem, who had trained as an engineer. Johanna started working on an English translation of the letters, but died in 1925 before completing it.

Vincent Willem van Gogh took over the responsibility of promoting his uncle's fame, and resolved to sell no more paintings. He thus kept together a vast body of works, thereby inflating the price of any which came onto the market. By the 1950s he was theoretically the richest man in Holland, and the tax payable on his death would have been phenomenal. A Vincent van Gogh Foundation was created and endowed with sufficient money to buy the entire collection. It was then housed in a specially built gallery, the Rijksmuseum Vincent van Gogh in Amsterdam, close to the older Rijksmuseum.

Vincent Willem van Gogh died in 1978. By his marriage to Josina Wibaut (who died in 1933, at the age of forty-three) he had four children: Theo was executed by the Germans in 1945, at the age of twenty-five, but Johan, Florentius Marinus, and Mathilde Johanna are still alive.

BIOGRAPHICAL INDEX

BONGER, Andries (1861-1939).
A friend of Vincent and Theo in Paris.
Theo married Bonger's sister Johanna,
later the editor and translator into
English of Vincent's letters.

BERNARD, Emile (1868-1941).
Studied painting at Cormon's atelier,
where he became a friend of van Gogh,
and went painting with him in Asnières
in 1887. They maintained close contact
when Vincent left Paris, and exchanged
letters. After Vincent's death, Bernard
helped Theo van Gogh arrange Vincent's
commemorative exhibition.

CORMON, Fernand (1845-1924).
Successful academic painter who ran a
liberal teaching studio and was a
Professor at the Ecole des Beaux-Arts. He
numbered amongst his more famous
pupils van Gogh, Gauguin, Toulouse-
Lautrec, and Emile Bernard.

DIMMEN, Gestel.
A villager from Nuenen who took
painting lessons from van Gogh in 1885.
He was the son of a printer who
specialized in the production of cigar-
bands, and who provided the
lithographic stone on which Vincent
produced prints of *The Potato Eaters*.

FÉNÉON, Félix (1861-1944).
Writer, art critic, and active anarchist
(although a civil servant by profession),
he was critical of Impressionism, and a
defender of Seurat, Signac, and the Post-
Impressionist painters.

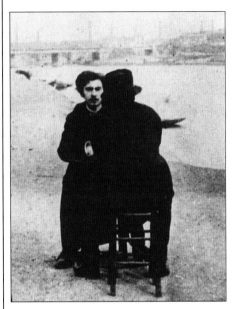

EMILE BERNARD WITH VINCENT IN 1886 AT
ASNIERES, WHERE BERNARD LIVED AND WHERE THE
TWO USED TO GO PAINTING. BERNARD IS FACING
THE CAMERA. PHOTOGRAPH TAKEN WITH THE AID
OF AN AUTOMATIC SHUTTER-RELEASE.
AMSTERDAM, VAN GOGH MUSEUM
VINCENT VAN GOGH FOUNDATION

GACHET, Dr. Paul (1818-1909).
Homeopathic doctor, psychiatrist,
Socialist, Darwinian, and engraver, he
was a friend and patron of the
Impressionists. Dr. Gachet played an
important role in the last few weeks of
Vincent's life by giving him help and
encouragement at Auvers. He also taught
Vincent etching.

HAGEMAN, Victor (c.1865-1928).
A fellow student of van Gogh at the
Antwerp Academy, Hageman appealed
to Vincent through his interest in
painting poor immigrants and scenes
from the life around the docks. He gave a
very vivid account of van Gogh during
his Antwerp period to Louis Piérard, who
published it in his *The Tragic Life of
Vincent van Gogh* (London, 1925).

HARTRICK, Archibald Standish
(1865-1950). Scottish student at Cormon's
atelier, who later became a well-known
engraver and book illustrator. One
chapter of his autobiography is devoted
to his Parisian period, and contains a
detailed account of van Gogh.

LAVAL, Charles (1862-94).
Friend and disciple of Gauguin, with
whom he went to Panama. Laval was
also very close to van Gogh, with whom
he exchanged paintings, and he attended
Vincent's funeral. Laval married Emile
Bernard's sister, and died of tuberculosis
in Egypt.

LIVENS (Lievens), Horace (1865-1932).
After beginning his career at the Croydon
College of Art, Livens moved to the
Antwerp Academy, where he got to
know Vincent, and painted a portrait of
him (see page 109). On van Gogh's advice
Livens went on to Paris, and then
returned to London, where he had a
reasonably successful career in an
Impressionistic style. Van Gogh wrote
several letters to him from Arles.

MacKNIGHT, Dodge (1860-1950).
American artist, later a member of the
group of "quietist" painters, who lived
and worked at Fontvieille near Arles. He
frequently visited van Gogh when he was
in Arles. Vincent did not like MacKnight
very much, but tolerated him because he
thought him wealthy, and hoped that he
might support an artists' colony.
MacKnight was a friend of John Russell,
and had worked at Cormon's studio.

MAUVE, Anton (1838-88).
Vincent's cousin, an important influence
in his early life and his artistic education.
A self-confident man, though subject to
bouts of clinical depression, Mauve
represented the influence of the Barbizon
School, and was a dominant figure in the
art world of The Hague. Vincent studied
with him in 1881-3, but broke with him;
in a heated moment, Mauve told Vincent,
"You have a vicious character." When
Mauve died, however, Vincent inscribed
"Souvenir de Mauve" on a painting of pink
peach trees in blossom.

MILLIET, Paul-Eugene (c.1863-c.1941). Second lieutenant in the Third regiment of Zouaves stationed in Arles, and an enthusiastic amateur painter. Milliet became friendly with Vincent and went on painting excursions with him, as well as sitting for him.

MONTICELLI, Adolphe Joseph Thomas (1824-86). A great hero to van Gogh, he was a romantic artist who used colors of violent intensity, applied in swirling impasto. He lived and worked for most of his life in Marseilles, but had a widespread international reputation, especially in Scotland.

PEYRON, Dr. Théophile (1827-95). Director of the Asylum for the Alienated of Saint-Paul-de-Mausole, near Saint-Rémy-de-Provence, from 1874. Originally in the naval Medical Service, he specialized in nervous diseases before taking the job at the Asylum. He diagnosed Vincent as suffering from "acute mania, with hallucinations of sight and hearing. . . . It is my opinion that M. van Gogh is subject to epileptic fits at very infrequent intervals." He prescribed bromides, opiates, and hydrotherapy.

PISSARRO, Camille (1830-1903). One of Theo van Gogh's artists, he was a supporter of the younger generation of artists such as Gauguin. This pillar of the Impressionist movement was kind to Vincent, and supported the small exhibition at the Grand Bouillon restaurant in the avenue de Clichy in 1886, in which van Gogh participated.

PISSARRO, Lucien (1863-1944). Camille Pissarro's eldest son and a painter and engraver in his own right. He and van Gogh became friends, and Vincent gave Lucien a still life with apples, receiving in exchange a group of engravings. Lucien attended Vincent's funeral in Auvers.

RAVOUX, Arthur-Gustave. Owner of the inn at Auvers where van Gogh stayed during the last two months of his life. The Ravoux family were rather distant from the painter during his stay with them, always calling him "Monsieur Vincent," but they encouraged the van Gogh cult after his death.

REY, Dr Felix (1867-1932). A young intern who looked after van Gogh in the hospital at Arles. An intelligent man – he was working on a thesis for the University of Montpellier, and had been awarded a silver medal for his work in a recent cholera epidemic – he had advanced ideas about the treatment of psychosis and was very sympathetic to Vincent.

RUSSELL, John (1858-1931). Born of well-to-do parents in Sydney, Australia, he came to Paris to study art at Cormon's studio in 1884. He became very friendly with van Gogh, and first recommended Arles to Vincent as a suitable place to stay and paint. The delights of Provence had already been emphasized by Toulouse-Lautrec, and Russell already had a friend there, Dodge MacKnight. After Vincent had moved

south, he and Russell maintained an intermittent correspondence for the rest of van Gogh's life. Russell eventually returned to Australia, where he had a long and very successful career.

SEGATORI, Agostina.
Born in Naples, she had come to Paris as a model. She posed for Corot amongst others, and became attached to August Hagborg, a Swedish artist much younger than herself. When Hagborg left her and she became too old for modeling, she bought a restaurant in the Boulevard de Clichy. Le Tambourin (all the furniture and fittings were tambourine-shaped) soon became famous for its food, and was frequented by Toulouse-Lautrec and van Gogh. It was in the Tambourin that Toulouse-Lautrec painted his portrait of Vincent (see page 113), and Vincent painted the self-portrait on page 75. Van Gogh also painted a portrait of Segatori in 1888 (now in Amsterdam, at the Van Gogh Museum).

SIBERDT, Eugeen (1850-c.1910).
Drawing master at the Antwerp Academy when Vincent was a student there in 1886.

"SIEN" (1847-1904).
The nickname of Christine Clasina Maria Hoornik, a prostitute from a respectable family. Vincent lived at The Hague with her in 1882-3. Sien was pregnant when she met Vincent, and already had an illegitimate daughter. She made additional money by taking in washing. Eventually, she committed suicide.

SIGNAC, Paul (1863-1935).
A mostly self-taught landscape painter, Signac was largely responsible, together with Georges Seurat, for creating and developing the Pointillist style. This used small, juxtaposed "points" to create the required color. Signac met van Gogh in the winter of 1886-7, and had a perceptible influence on his work. Signac later abandoned Pointillism.

TOULOUSE-LAUTREC, Henri de (1864-1901). The son of a count, deformed by an inherited disease, he converted lithography and the poster into major art forms. Versatile, witty, alcoholic, yet hard-working, Toulouse-Lautrec recorded the life of Montmartre with verve and panache, and immortalized the popular theater of the period. He met van Gogh at Cormon's atelier and for a time they were inseparable friends, exchanging paintings and making the round of cabarets and clubs.

VAN RAPPARD, Anton (1858-92).
An aristocratic young artist, he introduced himself to Theo van Gogh in Paris. Van Rappard later went to the Academy in Brussels when Vincent was there, and allowed him to share his studio. Vincent's series of portrait heads, painted in imitation of what van Rappard was doing, was the real beginning of van Gogh's interest in the genre. The two fell out over Vincent's *The Potato Eaters*, which van Rappard criticized fiercely. An attempt at a reconciliation was made, but nothing came of it.

BIBLIOGRAPHY

It would be impractical to present a complete bibliography of the vast amount of literature which has appeared about van Gogh. This is a selection relevant to the theme of this book, or of value to the general reader.

Bailey, Martin (ed.),
Vincent van Gogh: Letters from Provence,
Collins and Brown, London, 1990

Clébert, Jean-Paul and Richard, Pierre,
La Provence de van Gogh,
Edisud, Aix-en-Provence, 1981

Erpel, Fritz,
Van Gogh; Self-Portraits,
Bruno Cassirer, Oxford, 1964

De la Faille, J. B.,
The Works of Vincent van Gogh,
Weidenfeld & Nicolson, London, 1970

Galbally, Ann,
The Art of John Peter Russell,
Sun Books, Melbourne, 1977

Gauguin, Paul,
Intimate Journals,
trans. Van Wyck Brooks,
Liveright, New York, 1921

Hartrick, A. S.,
*A Painter's Pilgrimage
through Fifty Years,*
Cambridge University Press, 1939

Rewald, John,
*Post-Impressionism from Van Gogh
to Gauguin,*
Third edition, Museum of Modern Art,
New York, 1978

Roskill, M.,
*Van Gogh, Gauguin, and the
Impressionist Circle,*
Thames & Hudson,
London and New York, 1970

Sheon, A.,
"Monticelli and van Gogh" in *Apollo,*
June 1967

Sweetman, David,
*The Love of Many Things:
a Life of Vincent van Gogh,*
Hodder and Stoughton, London, 1990

Tralbaut, M. E.,
Vincent van Gogh,
Macmillan, London, 1965

Van Gogh à Paris,
Exhibition catalog,
Musée d'Orsay, Paris, 1988

Van Gogh-Bonger, Jo (ed.),
Vincent van Gogh; The Complete Letters,
Three vols, Thames and Hudson,
New York and London, 1958
(This is the one indispensable publication.)

Van Uitert, E. and Hoyle, M. (eds),
The Rijksmuseum Vincent van Gogh,
Meulenhoff-Landshoff, Amsterdam, 1987

Wolk, Johannes van der,
*The Seven Sketchbooks
of Vincent van Gogh,*
trans. Claudia Swan,
Thames & Hudson, London, 1987

Zurcher, Bernard,
Vincent van Gogh: Art, Life and Letters,
Rizzoli, New York, 1985

NOTE

With an artist as prolific, and as unknown in his own lifetime, as van Gogh, there is bound to be disagreement about not only how many paintings he made – current estimates vary between 870 and 930 – but also about the authenticity and provenance of many of these. While every effort has been made to ascertain the owners and copyright holders of the works included in this volume, the producers and publishers will be pleased to rectify any omissions in future editions.

ORIGINALS AND REPRODUCTIONS

The images in this book have been printed to the highest standards of color reproduction. This is necessarily dictated by the offset litho process, and the printed results cannot be a substitute for the original paintings, with their surface energy, depth of color, and often thick, deep, textured paint. To see van Gogh's (and any other artist's) work as it was meant to be viewed, visit the museums and art galleries where it is held.

ACKNOWLEDGMENTS

In addition to the institutions that provided portraits, the producers would like to thank the following:
CAROLINE POST, BRIDGEMAN ART LIBRARY, LONDON, for help with pages 61, 69, 79, 87, 101 and 129;
RICHARD VAN DIJK, TILBURG, for the image on page 6;
RONALD PEETERS, TILBURG, for the image on page 17 (top);
AD MOLENDIJK, DORDRECHT, for the image on page 17 (bottom);
CHRIS PERRY, HOVE, for help with page 88;
DR. HILARY GASKIN, CAMBRIDGE, for help with page 123;
DR. STEPHAN KOJA, VIENNA, for help with page 73.

144